Your Baby Is Speaking to You

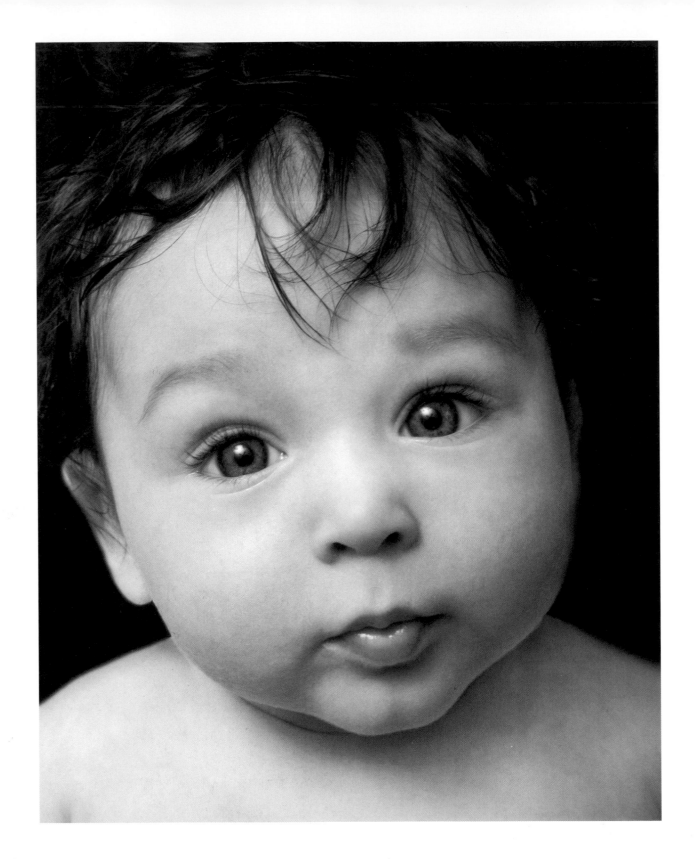

Your Baby Is Speaking to You

a visual guide to the amazing behaviors
of your newborn and growing baby

Kevin Nugent, Ph.D.

Abelardo Morell

 HOUGHTON MIFFLIN HARCOURT BOSTON NEW YORK 2011

For information about permission to reproduce
selections from this book, write to Permissions,
Houghton Mifflin Harcourt Publishing Company,
215 Park Avenue South, New York, New York 10003.

www.hmhbooks.com

Library of Congress Cataloging-in-Publication Data
Nugent, Kevin.
 Your baby is speaking to you : a visual guide to the
amazing behaviors of your newborn and growing
baby / Kevin Nugent.
 p. cm.
 ISBN 978-0-547-24295-8
 1. Infants—Development. 2. Parent and infant. I. Title.
HQ774.N84 2010
305.232—dc22 2010017207

Book design by Melissa Lotfy

Printed in China

SCP 10 9 8 7 6 5 4 3 2 1

To Una, Aoife, and David Declan—le mo bhuiochas, mo ghra go deo.

—J. KEVIN NUGENT

To Laura and Brady, who once were my babies.

—ABELARDO MORELL

Contents

Introduction

Shortly after I came to Children's Hospital in Boston more than three decades ago, I had the opportunity to attend hospital rounds with Dr. Berry Brazelton, acknowledged even then as a pioneer in infancy research. I still remember watching the steel-framed crib being wheeled into a quiet corner of the newborn nursery and seeing the tiny one-day-old infant, tightly swaddled, her head covered with a cotton bonnet, with only her small pink face peeping out. We all became silent as the young mother entered. She sat by the crib with an expression of anxiety and vulnerability, understandably self-conscious in the presence of the white-coated observers.

As Dr. Brazelton began to unswaddle the baby, I did not know what to expect. Not yet a father, I assumed that a one-day-old was just a very tiny baby, nothing more. He tested her foot reflexes and flexed her arms and

legs, examining her muscle tone. By now the baby was wide awake, and suddenly Dr. Brazelton was holding a red ball about twelve inches from her eyes. Can a newborn baby really see? I wondered. At that very moment her eyes locked onto the bright ball and began to track it. "She can see!" the mother blurted, shaking her head in disbelief. When Dr. Brazelton began to talk to the baby in lilting tones — using her first name, Sarah — her eyes widened and brightened. There was nothing random about her responses now. Her look was steady, and there was a sureness to the back-and-forth, give-and-take rhythm of the interaction between baby and doctor.

It was on that day that I encountered for the first time the powerful gaze of the human newborn. This one-day-old baby was no passive organism waiting for the world to shape her destiny. Sarah's ability to see and hear was indisputable, but it was her seemingly natural curiosity, her readiness to engage and connect with her environment that so impressed me. She was indeed a person. But when I caught sight of the young mother, her eyes now filled with tears as she pressed her infant close to her breast, repeating her name, no longer conscious of our presence, my thoughts were arrested for the second time that day. I was struck by the strength and tenderness of the mother-infant bond. It was as if this mother had just discovered the sheer depth of her feelings toward her baby.

But if the relationship between Sarah and her mother was transformed on that day, so was I profoundly changed. Indeed, I link my professional interest in child development to that moment. Witnessing this newborn's amazing capabilities and the dramatic effect they had on her mother in those early hours of her life on that winter day at the old Boston Lying-In Hospital was undoubtedly instrumental in turning my life in a new direction. It was only later that I came to realize that it was an experience in my own childhood that had infused this change of direction with such an unexpected sense of predestined certitude.

My response to baby Sarah was an echo of the time when I cared for my own baby brother after our mother died. I was not yet eleven years old, so the loss of my mother seemed like the end of love and security. I felt abandoned and alone, overwhelmed by feelings of vulnerability, sadness, hurt, emptiness, and loss. But looking after my baby brother—holding him, feeding him, changing him, playing with him, wheeling his pram down the street in our small town in Ireland—somehow drew me out of my grief and loneliness. It enabled me to fill in the emptiness and rebuild my sense of trust in a world that had seemed suddenly devoid of love and security. The experience set me on a path to recapturing my original innocence and grasping some element of hope.

Over the years, with a certain inevitable determinism, my work at Children's Hospital has tended to focus on the capacity of babies to connect with and have a transforming effect on their caregivers. Research has made it clear that babies are biologically programmed to be pro-social organisms who actively seek contact with those around them. The social newborn is indeed a masterpiece of creation, with the capacity to change and transform all who come into his orbit.

Your Competent Newborn

Because they are born with a rich behavioral repertoire, newborns are able to engage in face-to-face, eye-to-eye exchanges for brief periods. This readiness to connect with their caregivers is made possible by a wide range of visual, auditory, and perceptual abilities that enable infants to explore the world around them.

We now know that babies are drawn more to human faces than to anything else and that they can even distinguish a happy expression from a sad one. A newborn's hearing is so fine-tuned that she can detect a missing beat in a musical pattern and, more important, can recognize the sound of her mother's voice. Babies have a well-developed sense of taste right from the start and can

also clearly recognize their mother's smell. And, because the sensory cortex is the most developed area of the brain at birth, a newborn's sensitivity to touch is already exquisitely developed.

But simply listing these discrete abilities does not do justice to the full richness of your baby's behavioral repertoire. It is how he integrates all these competencies in a coherent, even purposeful, way that reveals his unique, individual personhood. Taken together, these remarkable capacities enable your infant to face the major developmental task that lies ahead, namely to form an enduring attachment bond with you.

The Language of Babies

The word "infant" derives from the Latin *infans,* meaning unable to speak. But even though babies cannot speak, they have a wide range of stunningly precocious communication strategies. Some of their communication cues are clear and unambiguous, open invitations to interact or engage or to move away and disengage, while others are not so easy to interpret. Your baby's signaling strategies are beautifully designed to draw attention and thus ensure her survival and adaptation. Her language can be as clear as a good loud cry ("Help me") or as subtle and fleeting as a puckering of the brow to

indicate slight displeasure ("This interaction is a little too intense for me"). It can be a bright-eyed look ("This is interesting") or a faint change of facial color ("I'm slightly stressed, please give me a short break"); a tiny sleep smile ("I am at ease, please don't disturb me") or a quickening in the pace of her breathing ("This is becoming too stimulating").

Whether it is an arching of the eyebrows or a furrowing of the brow, a splaying of the fingers or a tightening of the leg muscles, these signals are the "words" or "phrases" your baby uses to communicate, the phonemes of his first language, his first words. These behavioral signals are not random: they convey messages, provide information, and tell you what kind of caregiving your baby needs to grow and develop, what he likes or prefers and what he does not like. *Your Baby Is Speaking to You* will tell you how to watch for and interpret all these signals.

The Truthful Response

baby's cues are trustworthy; there is no discrepancy between the feeling and its expression. In fact, the facial and vocal emotional expressions of newborns may be more subtle than those of older children or adults. But unlike adults, babies cannot mask their feelings. Your baby's behavior is a

dependable window into his mind and feelings. Whether it is a prolonged, full-blown cry, a flicker in the upper eyelids, or a dazzling social smile, it is an authentic response, one that you can trust unconditionally.

Because they already appreciate at some level that their survival is on the line, babies are tuned in to a caregiver's behavioral cues. Your baby is exquisitely sensitive to every reassuring touch, word, and joyful exclamation. All of your loving responses deepen your baby's feelings of well-being and security and leave their imprints on her brain.

Understanding Your Baby's Language

arents and other caregivers lament, often with some hard-won humor, that babies do not come with an owner's manual. But in fact your infant does come with caregiving guidelines embedded in his behavior, which can tell you what he needs to survive and thrive. These guidelines do have to be decoded, however. And because each infant is different, with a distinctive disposition and sensibilities, each one's guidelines are unique. As you learn to decode your baby's behavior, he will offer you very precise information about his preferences, needs, and expectations—about who he is!

Your Baby Is Speaking to You is designed as a guide to unlocking your baby's code and reading his language, so you can listen to his voice and understand what he is saying. Taken together, the text and photographs will help you refine your observational skills, learn to recognize your baby's cues, and discern their meaning. As you encounter each of the expressions, postures, and movements portrayed in these photos and explore their meaning in the text, you will be preparing yourself for the thrilling experience — one I have been privileged to witness in new parents many, many times — of recognizing them in your own baby.

This Is Your Baby

Your Baby Is Speaking to You is not simply a summary of research over the years on the remarkable capacities of babies; it is a book that will help you get to know your baby as a person and allow you to grow into your own skin as a parent.

The book does not set out to offer advice on how to care for your baby. There are many wise books for parents and, indeed, many wise people in your community to whom you can turn for advice. Here, however, you'll find photographs and descriptions of infant behaviors and expressions, along with in-

formation on how they came to be and what they mean in terms of a baby's growth and development. This visual guide will help you recognize these behaviors, even the most transient and subtle ones, in your baby so that you can respond to her in the way she expects and needs. If this book acts as a key to unlocking the mysteries of your baby's behavior and thus makes the process of getting to know her satisfying and joyful, it will have fulfilled its goal.

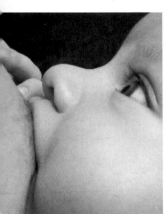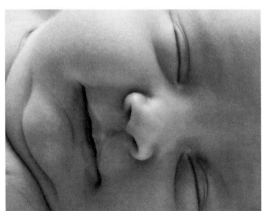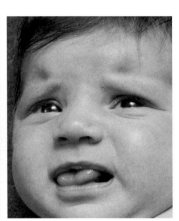

Sleeping, Crying, Eating

The Sleeping Baby

Babies are designed by nature to captivate us. Their helplessness seems to draw out our purest protective instincts, thus ensuring their survival and healthy development.

Your baby's very appearance — the rounded cheeks, the wisps of hair, the tiny, perfectly formed fingers and toes, the smooth skin, the soft, dimpled arms and legs — arrests and captures your attention. His large eyes and alert gaze lure and hold you in his thrall. Even when he is asleep, the image is just as compelling.

Do you find yourself hovering over the crib late at night, lovingly contemplating your baby as she sleeps? Not only can you appreciate the beauty of her perfect little body while she is asleep, this is also a time when you can stand back and appreciate her as a distinct person in her own right. The sight of your unspoiled sleeping baby may stir your imagination and remind you of the opportunity you have to give her what she needs to grow and develop in life. On a more mundane level, it may be that only when your baby is asleep can you turn to other aspects of your life, knowing that she is settled and content and does not need you, at least for now. Could it be that watching a sleeping baby reminds us of the profound gift of time?

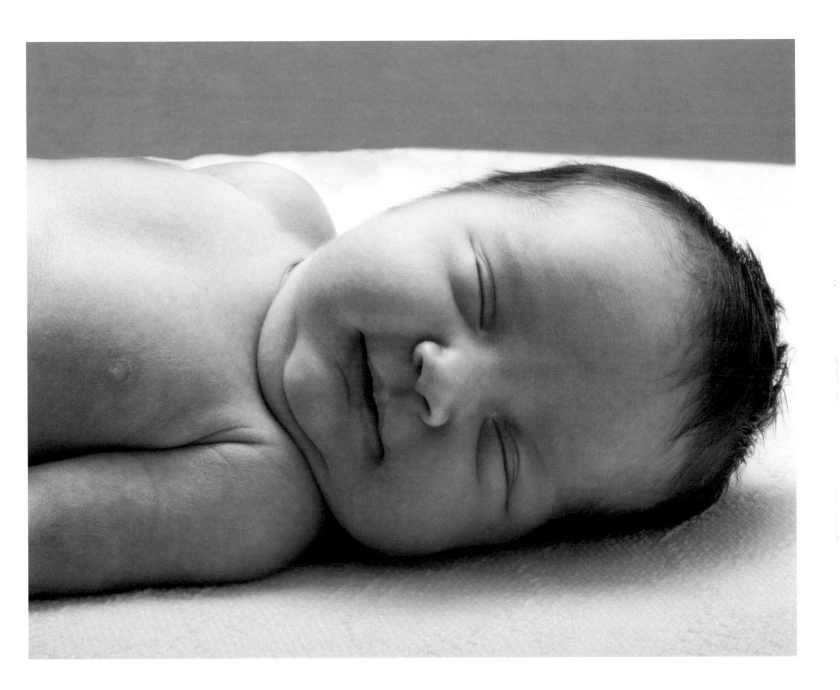

Deep Sleep

AT FIRST GLANCE, your sleeping baby appears to be doing nothing. But there is more to a newborn's sleep than meets the eye. Babies have two kinds of sleep — deep sleep and light sleep, which play very different roles in their development.

This baby is in a deep sleep. His face is tranquil — not a wrinkle on his perfect brow, no hint of a flicker of his eyelids. In fact, there is scarcely a movement in his body, except for the gentle rise and fall of his chest as he breathes. As you watch your sleeping baby, you may see a sudden sleep startle coupled with a change in breathing, followed by an immediate return to deep sleep. This sleep phase, which is associated with lower oxygen consumption and the release of growth hormones, is restorative, giving your baby the energy to respond to you and feed successfully when he wakes up.

Being able to stay asleep in a very different environment from the relatively peaceful world of the womb is an astonishing achievement. Now your baby has to learn to preserve his sleep in the face of an ever-changing world of faces and voices, sounds and lights. To recover from labor and delivery and to adapt to his new world, your newborn needs to sleep from sixteen to eighteen hours a day, or approximately 60 to 70 percent of the time, but rarely for longer than four and a half hours at a time.

In deep sleep, a baby is able to selectively tune out sounds and bright lights. This capacity to screen out sounds that do not "matter" to him — sounds that are loud, sudden, or repetitive — is marvelously adaptive. Some more sensitive babies, though, may find it difficult to cope with higher levels of environmental stimulation. Babies with low tolerance for outside stimulation have to use a great deal of energy trying to protect their sleep. They may have little strength left for feeding or for playing when they are awake. Your baby may need to be securely swaddled or moved to a quieter place with more muted light in order to maintain deep, prolonged sleep. With time — and some support from you — your more sensitive baby will learn to manage his sleep at his own pace.

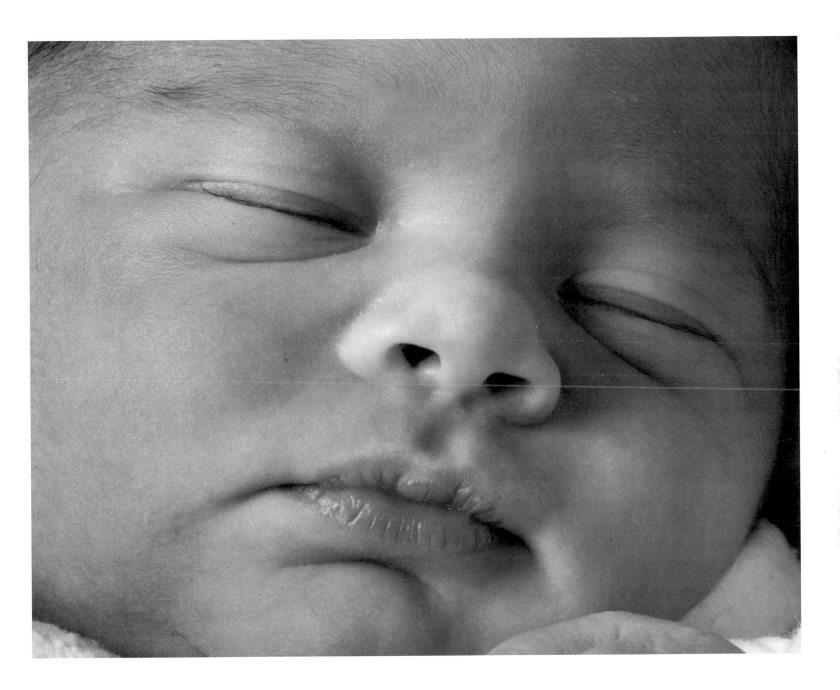

Light Sleep

THIS SLEEP PHASE is often called light or rapid eye movement (REM) sleep, because the baby's eyes can be seen to flutter behind his softly closed eyelids. His whole body occasionally moves as if he were stretching. Still, he will soon settle back to sleep, his legs and arms back in place. If you look closely at your baby in REM sleep, you may see his facial expression change—he may open his mouth, purse and pucker his lips as if sucking on an imaginary nipple, wince or wrinkle his nose, or tighten his eyes—but he does not wake up. Sometimes you may even see a faint half-smile on his face.

Before they are born, babies sleep most of the time. As they come closer to term, though, their sleep patterns become more regular. Quiet periods with no body movement alternate with more active sleep states. Newborns spend almost half of their sleep time in REM sleep, which, many researchers believe, stimulates the brain and is associated with processing and storing information. In addition, the eye movements during REM sleep periods activate a gelatinlike substance that helps keep the eyes fully oxygenated.

If you chart your baby's behavior over the course of a day and night, you will notice the gradual appearance of a cycle, with periods of quiet sleep following periods of deep sleep. Developing predictable sleep-wake patterns is a steppingstone to developing the capacity to sleep through the night, a task that you and your baby will be facing over the months ahead.

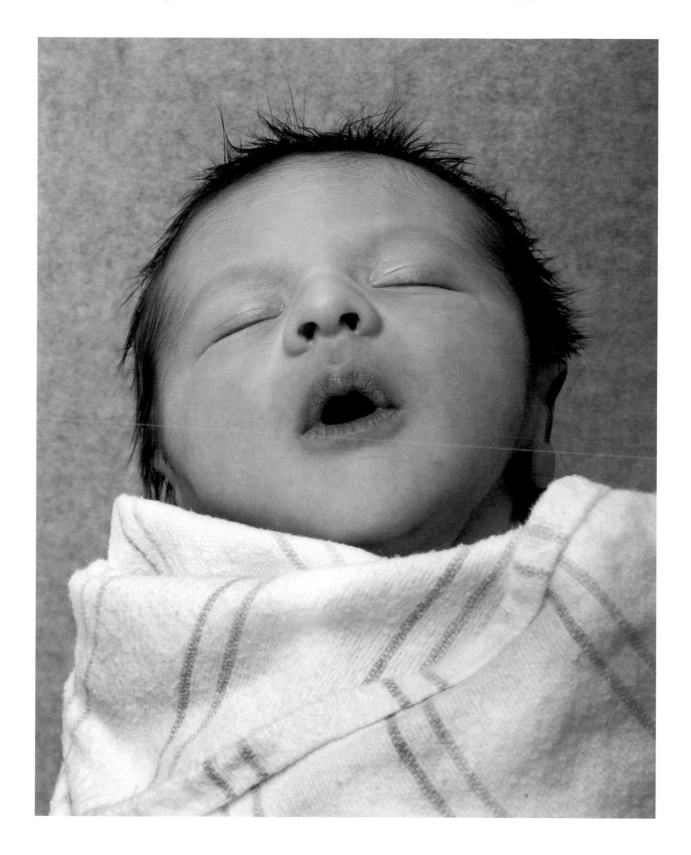

The Full Cry

Few of us, parents or nonparents, can remain unmoved by a baby's full cry. It stops us in our tracks. The longer the cry lasts, and the higher-pitched and more insistent it becomes, the more likely we are to experience some of the baby's distress ourselves. Your baby's soft, round face has suddenly changed its shape and is now charged with deep color. The perfect contours of her mouth are stretched, her brow is wrinkled, and her legs and arms may flail out of control. You may be surprised to learn that crying does not produce tears until after a baby is a month or two old, but it does not take tears to tell you that a full cry is an unambiguous call for help. At no other time does your baby appear so helpless, so in urgent need of your intervention. You are inescapably drawn to pick her up and cradle her in the comfort of your arms.

Crying is a baby's most clear-cut form of communication, telling us that she is hungry, uncomfortable, overstimulated, exhausted, or in pain. Some babies' cries are easy to interpret, while others are more difficult to read. As you get to know your baby, you will find that her various cries differ in their intensity and loudness, their pitch and duration, even in their level of feeling. Hunger cries and cries of discomfort tend to begin softly and then to become loud and rhythmic. A cry of pain has a distinctive pattern, beginning with a single shriek followed by a short silence and then by continuous loud crying. A cry of pain may even include periods of breath-holding. Understanding why your baby is crying can be a challenge, but over time you will be able to recognize her different cries, which will make it easier to console her.

Just think what it would be like for your newborn if she could not cry or if her cry could not be heard. Your baby's cry — as disturbing as it is to your ears — is designed by nature to elicit appropriate soothing intervention from you. Your response to your baby's distress is profoundly consoling, making her feel that her new environment is safe because her cries for help are unfailingly answered. This is one of the primary ways your baby develops a deep sense of trust in you and in her new world.

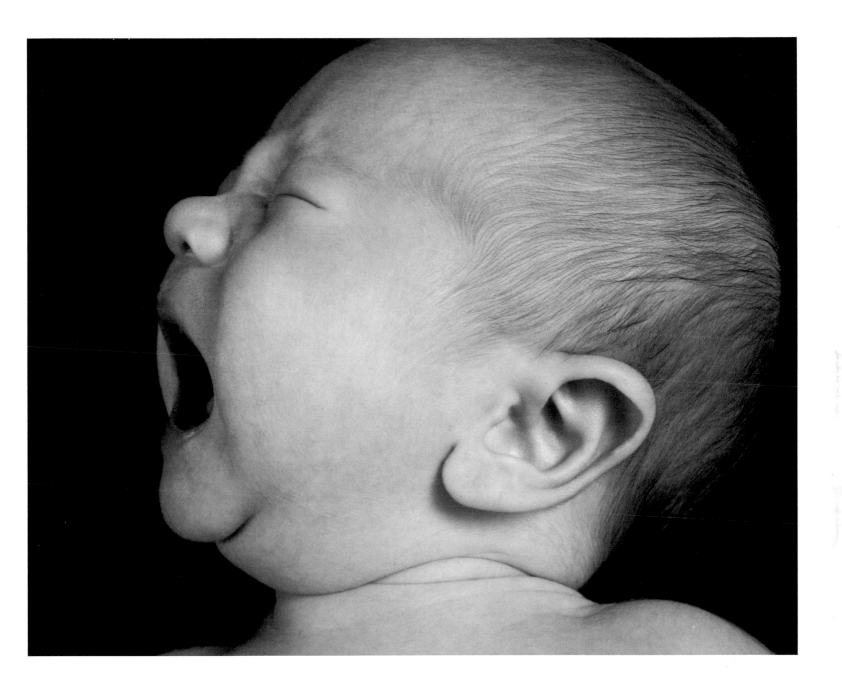

Fussing

ALL BABIES FUSS and cry in the first weeks and months of life, no matter how sensitive and consistent parents are in responding to their cries. Although babies differ in their crying patterns, there seems to be a peak in crying at around six weeks, followed by a gradual decrease at about four months of age. In these early weeks and months, your baby may cry more in the late afternoon and evening, although babies who fuss and cry a lot do so throughout the day.

Fussing is a lower-pitched, less intense form of crying and does not include the open-mouthed "cry face" or the body tension that accompanies a full cry. A fussing baby does not appear to be as desperate as when he is in a full cry. While fussing may be accompanied by an increase in activity—you will see the inner corners of your baby's eyebrows angle upward, his brow crumple, and open-mouthed tonguing—neither the sound of his fussing nor his facial expression conveys the same urgency as a full cry. And fussing doesn't usually last as long as a bout of crying.

Though not as dramatic or arresting as crying, fussing does capture your attention—just as it is designed to do! By the time your baby reaches a full-blown cry, she is quite distressed and much more difficult to soothe. So when she begins to shift around fitfully and then starts to fuss, she is giving you a warning sign that she is on the verge of being extremely upset or even overwhelmed. As you become familiar with your baby's early stress signs, you will be able to respond to cues such as squirming or fussing and offer her the support she needs.

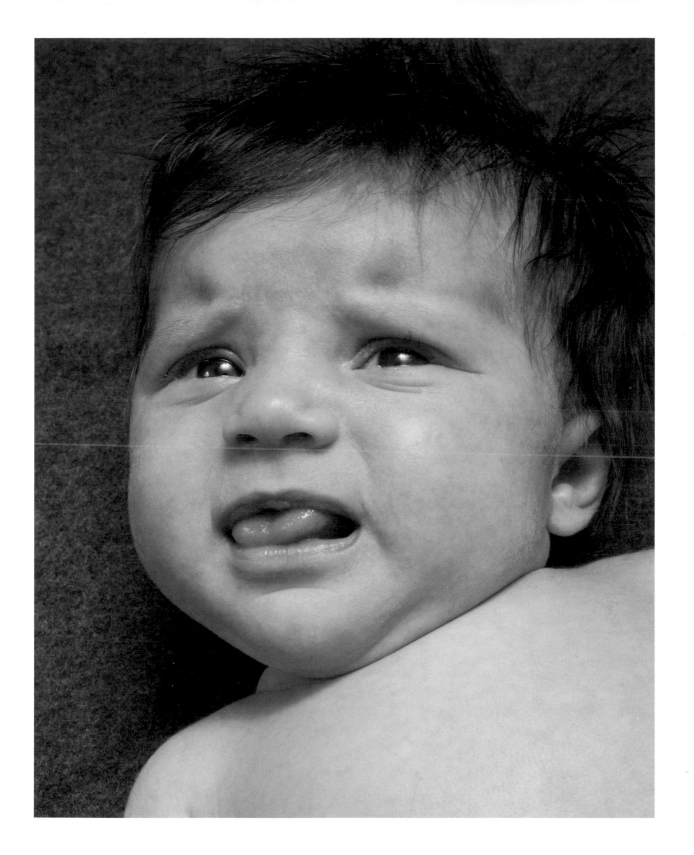

The Search Response

THE AREAS AROUND and inside a baby's mouth are exquisitely sensitive to touch. Sensitivity to touch begins to develop about eight weeks after conception and develops in a sequence from head to toe. The mouth is the first region to become sensitive.

Now, in the newborn period, your baby's mouth is more sensitive to touch than any other part of her body. If you stroke her cheek or lightly touch the area around her mouth, she will immediately turn and begin to search. The soft skin of her mother's breast most easily triggers this automatic rooting or search response, as it is called. The baby moves her head back and forth, opens and puckers her mouth, thrusts her lips forward, and moves her tongue. These movements seem purposeful, certainly determined. Only when she has succeeded in latching on to the nipple with her mouth and has begun to feed does she stop searching. She is now contented. Clearly, this is what she wanted all along.

In many languages, this behavior is called the breast-seeking response. In Spanish it is *reflejo de búsqueda;* in Italian, *riflesso di ricerca;* and in French, *recherche réflexe du sein.* All cultures recognize the behavior as elegantly designed to ensure that the baby can locate her source of food and thus be able to survive. Although this search response may mean that your baby is hungry, it may also simply be that her cheek has come in contact with your breast, causing her to turn in that direction. After a few weeks, the response diminishes as voluntary head-turning becomes more established; your baby can now move directly to the breast without any need to search. But in the early weeks, rooting is usually the primary signal that your baby is ready to feed.

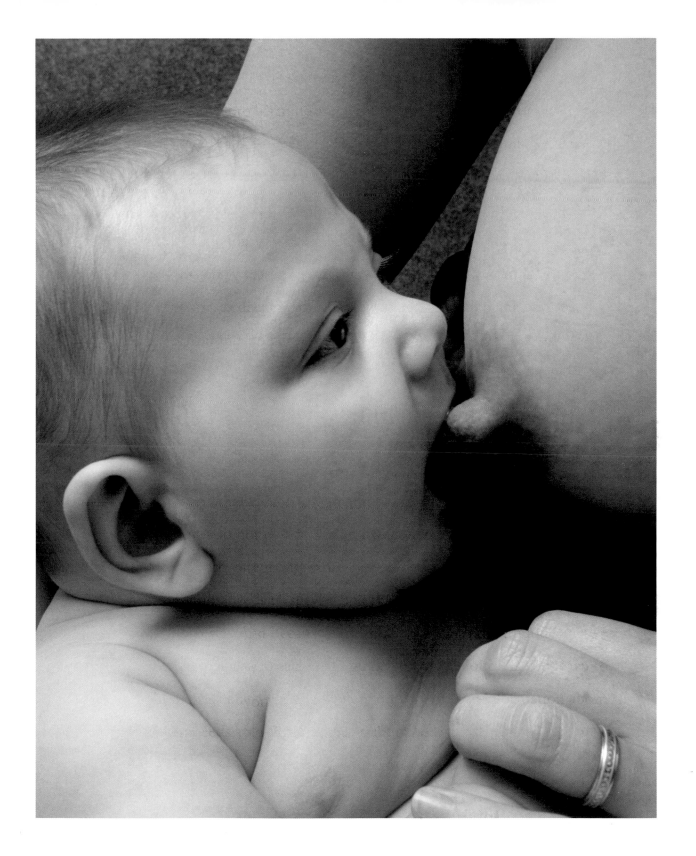

Feeding

THE FETUS DRINKS amniotic fluid whenever it makes sucking movements, but the newborn baby faces dramatic new challenges before being able to feed successfully. The baby's sucking response plays a key role in this task, whether he is breast- or bottle-fed. He has to learn to latch on to the nipple and to integrate his sucking and breathing in a smooth pattern without releasing the nipple to breathe. Some babies do this more easily than others. To ensure that feeding is a rewarding experience for both you and your baby, you should first make sure he is in a quiet but alert state. Then find the position that is most comfortable for him, recognize his cues, and avoid forced or prolonged attempts at feeding when he is fatigued or stressed.

While feeding is a satisfying time for most babies, some have less mature sucking responses, which may result in arching the back, gagging, or having difficulty swallowing. Also, many mothers experience pain and soreness from nursing, which can be distressing and disappointing for them. Although most such difficulties can be overcome with perseverance and patience, support from a lactation consultant or a mothers' group may be critical to helping mother and infant have a successful feeding experience.

If feeding at the breast is a perfectly satisfying time for the infant, it is also perfect for the nursing mother. Your baby's sucking excites nerves in your breast that send a message to the pituitary gland in the brain to release the hormone oxytocin, which signals the breasts to release milk. The high level of oxytocin also stimulates tender feelings toward the baby. When your infant has successfully latched on to your breast, you will see that every rhythmic syllable of her body language is telling you that all her needs are being met. Her primary need for sustenance, her need to feel safe, her need to be touched and held, her need to search out your eyes—all these are satisfied in this sublime moment of feeding.

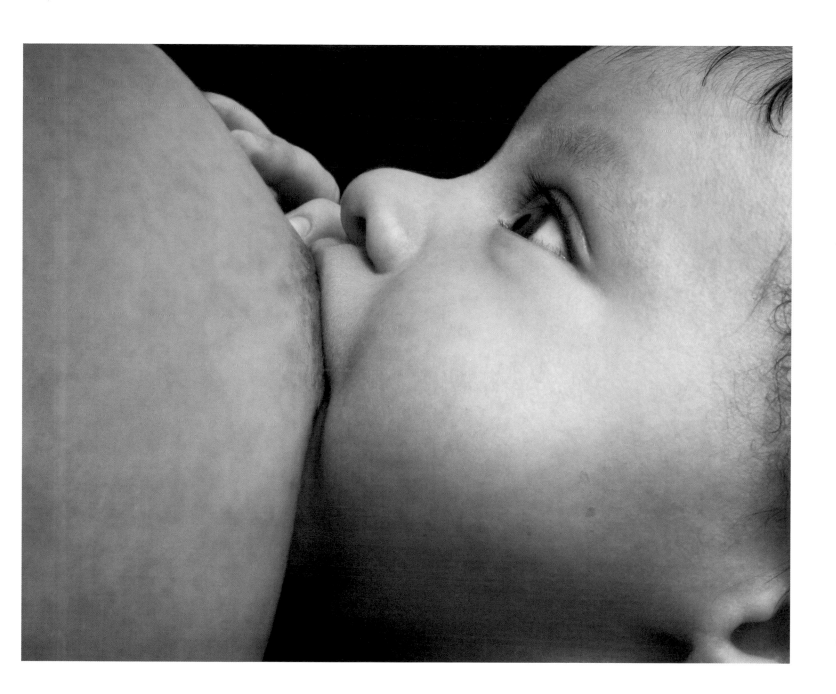

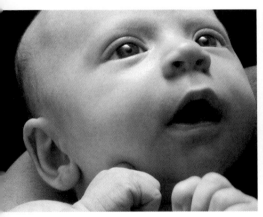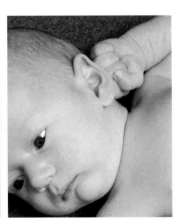

The Amazing Newborn

The Fencer Response

Have you noticed that while your baby is lying on his back, he seems to have a preferred side? Most infants tend to lie with their heads turned to one side or the other (usually the right), with their arms in a distinctive posture, sometimes referred to as the "fencer response" because the position is like that of a fencer taking his initial stance. Whichever direction your baby's face is turned, that arm will extend and the other will be flexed at the elbow. This postural preference or "position of comfort" seems to be a continuation of your baby's position of choice in utero, and by the time he is born, it is fairly well established.

The ability to maintain this posture gives an infant the stability and control he needs to organize himself and to focus and attend to his environment. The fencer response puts the hand of the extended arm within the baby's visual field. This may give him an awareness of distance. And it means that over the course of a day, your baby will often have a clear view of his hand. It's possible that this posture will influence his future reaching efforts, and it may also eventually determine his favored hand, the one he will use for writing.

Your baby may assume this posture as a coping strategy when he is upset. The fencer response enables him to find his hand, which he can then bring to his mouth and initiate sucking, which settles him. Your baby's spontaneous use of the fencer position is an invaluable self-organizing and self-consoling device. It allows him to calm himself so that he can begin to study his surroundings—at his ease.

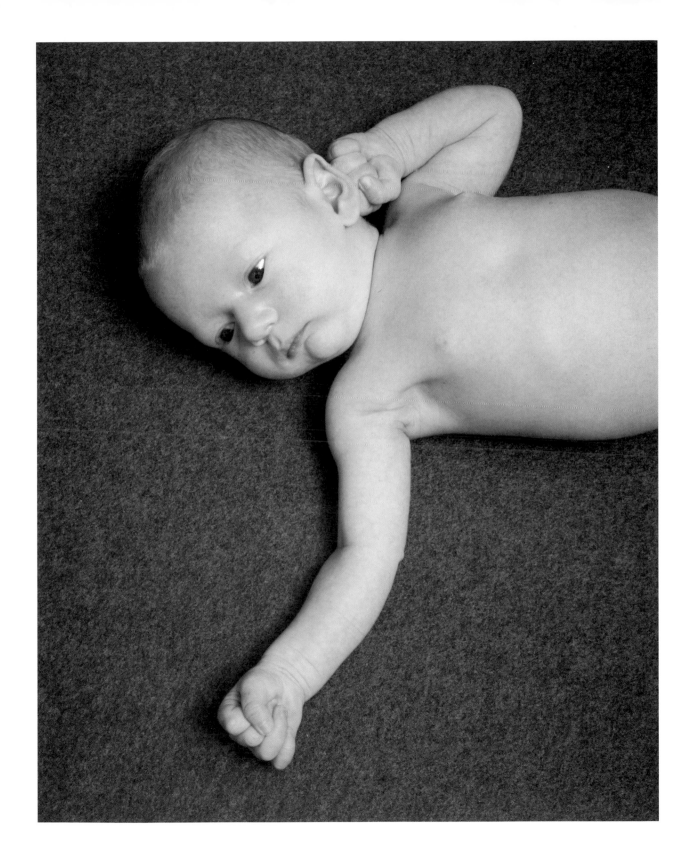

Hand to Mouth

YOUR BABY'S HAND movements may appear at first glance to be haphazard and without purpose, showing little evidence of control. But if you take a closer look, you will discover that these movements are not truly random or involuntary. In fact, your baby can use his hands in a purposeful-seeming way.

Nowhere is this behavior more evident than in a baby's remarkable ability to get his hand or fist into his mouth—even when he is not hungry. Your baby may not achieve all this with smooth, graceful movements, but you cannot help but be impressed by his sheer persistence and by the resulting gratification he seems to experience when he succeeds in getting his hand or fingers into his mouth.

Even more remarkably, your baby may be able to get hand to mouth when he is upset, usually after a long series of hits and near misses as he tries to coordinate his wavering hand with the movements of his head and mouth. When he does succeed in inserting his hand into his mouth, he begins to suck on it, which often helps him calm down and settle himself. This behavior is referred to as nonnutritive sucking, and, just as in feeding, it involves stable, rhythmically alternating bursts and pauses. Now

he is able to remain alert and examine his new surroundings. In this simple but remarkable act, your baby is showing you how competent he is and how, even in these early days, the urge to explore his new world is paramount. Fortunately, your baby comes well prepared for the task—the newborn is no neophyte.

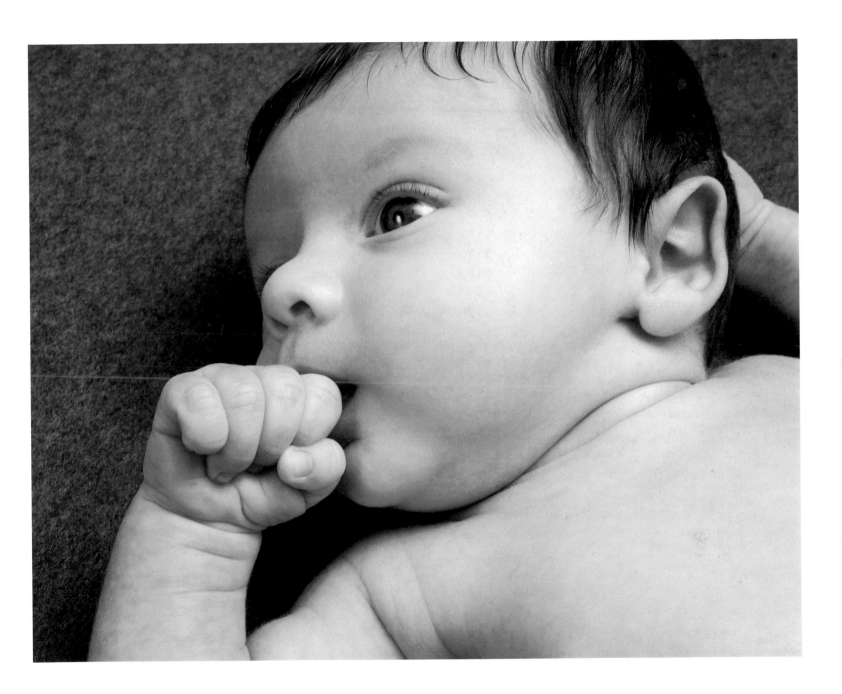

The Sleep Smile

In the beginning, most babies smile only while they are sleeping. These tiny smiles, which involve a turning up of the corner of the mouth with a slight raising of the cheek, can be seen especially during light REM sleep. These are called spontaneous sleep smiles because they are usually triggered by something within your baby rather than by some external cause.

So why is this one-day-old baby smiling? We know this cannot be a social smile, since that involves the muscles around the eyes and is seen only when your baby is awake and interacting with you. Some people call these early sleep smiles "gas smiles," assuming they are caused by some mild intestinal discomfort and thus have no real emotional significance. But how can we not believe that these lovely sleep smiles convey feelings of pleasure and contentment?

Could she be dreaming? Maybe. We do know that adult dreaming occurs during active or REM sleep and that newborn babies spend 50 percent of their sleep time in REM, almost twice as much as adults. So if you see a smile on your sleeping baby's face, it is possible that she is "seeing" images, maybe even of your face, but we really do not know.

Sometimes a sleep smile will appear as a response to your voice or to a soft sound, or even to the fleeting chime of a clock or a doorbell, usually about ten seconds after the sound. These sounds may boost your baby's excitement level above a certain threshold, and the smile comes with the relaxation that follows.

So even though your baby's early, fleeting sleep smiles are not true social smiles, she *is* telling you that she is contented, happy, doing what she should be doing, and that she does not want to be disturbed. Sleep smiles decline in frequency after the first weeks of life as your baby's bright-eyed, open-mouthed social smile begins to dominate. Perhaps she is just practicing!

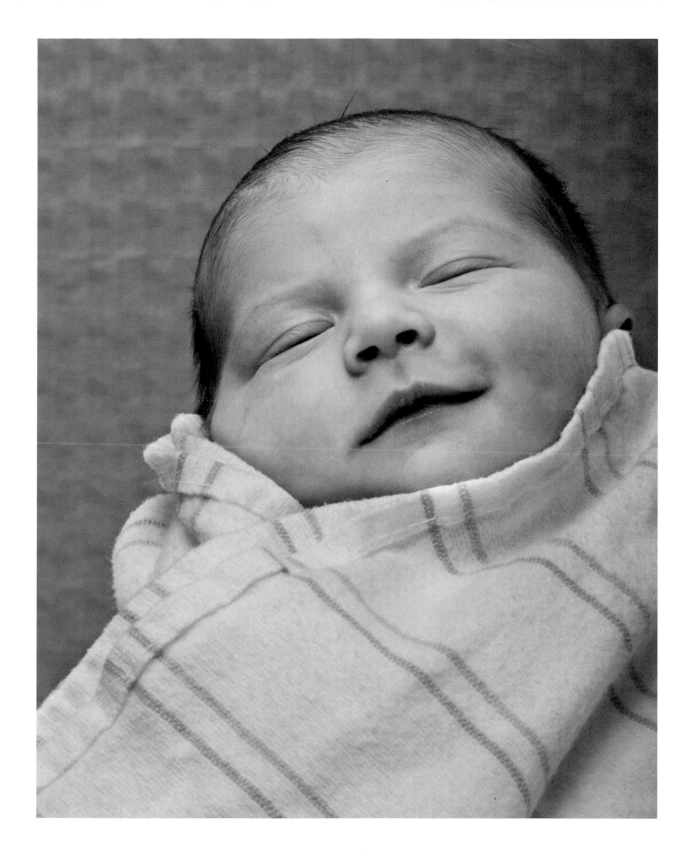

First Steps

PARENTS ARE USUALLY surprised—even startled—by their newborn infant's ability to take steps, though of course they realize that this behavior is not *really* walking. When you hold your baby in a slightly forward-leaning position, with his legs bearing some of his weight, and gently move him forward, he will take rhythmically alternating steps. This behavior disappears by six to eight weeks, probably because your baby's rapid increase in body weight coupled with his relatively weak muscles make it difficult for him to keep his body in an upright position. Over the next months, if you hold him upright and partially submerged in warm water, which makes his legs more buoyant and easier to lift, he will again produce alternating steps. The stepping response reappears later in the first year, when your baby begins to walk independently.

We are amazed at a newborn's walking response because we know that the infant is a slave to gravity and that he will not take his first independent step for many months. Could it be that we are fascinated by this behavior because in his act of walking we catch a glimpse of the future? Suddenly we can imagine our baby as he will be—independent, standing upright, stepping out, with the world at his feet! This precocious stepping response also hints at the continuous, progressive nature of development. Over the next twelve months your baby will move inexorably from a state of almost complete physical dependence to a state of independent locomotion and adultlike motor development. And you will have the privilege of playing a critical part in this journey by encouraging, supporting, and scaffolding that development every step of the way.

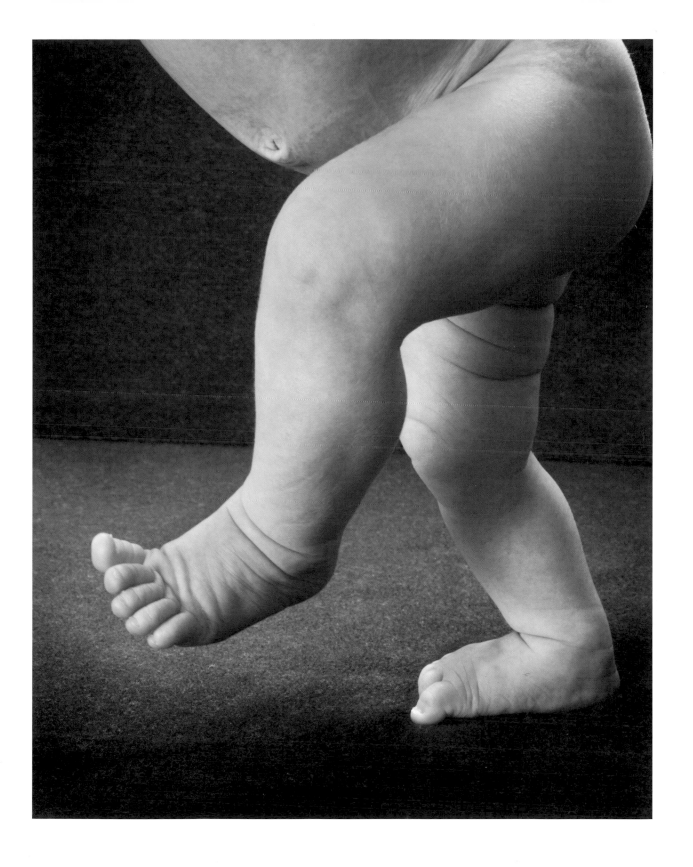

Hands

ALTHOUGH NEWBORNS ARE best able to feel with their mouths, their hands also have good touch sensitivity. When you place your finger on your baby's palm, her fingers automatically flex around it. This hand grasp may be less intense during the first few days, and it is absent during deep sleep, but you will notice it when she is in a light sleep as well as when she is awake and alert. We have seen that infants use their hands in ways that seem almost purposeful, and we know that the hand grasp is not totally automatic or involuntary. In your baby's first few weeks, you may notice that she can even explore objects with her hands and mouth—fingering and squeezing them to learn more about them.

Your baby's ability to grasp your finger can play a significant role in maintaining physical contact during feeding or when you are simply holding and cuddling her. You will be aware of the strength of her hand grasp from the beginning, and you can spontaneously integrate it into your routine feeding and play periods by holding out your fingers for the baby to grasp. Letting her grasp your finger is also a way to soothe or reassure her or to contain her random movements when she cannot control them herself.

By two months of age, your baby will keep her hands open most of the time, and around three months her hand-grasp reflex will be replaced by active voluntary grasping. She may clasp her hands together, grasp her blanket, or hold on to a bar of the crib. By this time, too, holding your baby's hands will become part of the more active play and feeding interactions that are at the heart of your relationship with each other.

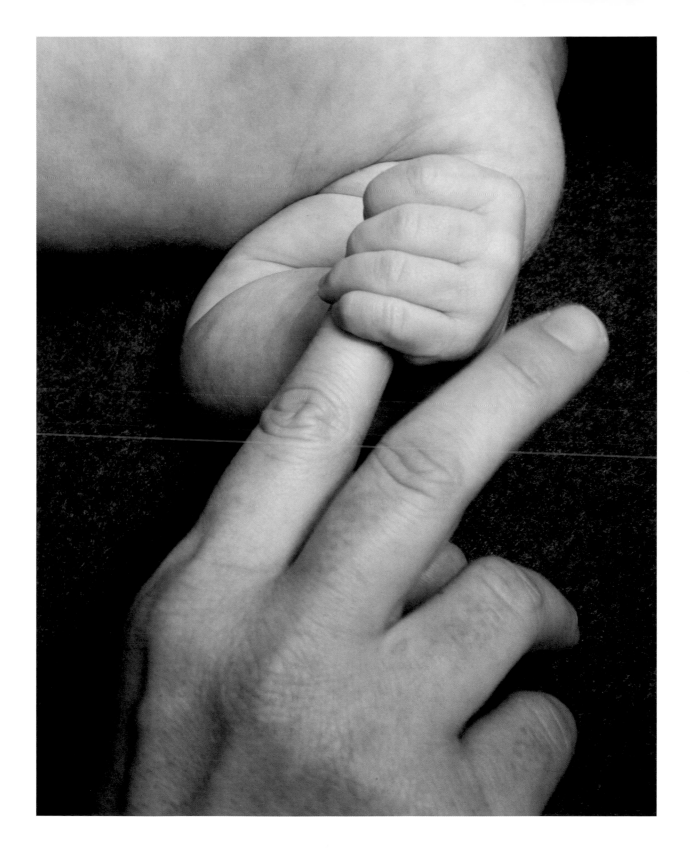

Pre-Reaching

YOUR NEWBORN BABY'S first movements often appear jerky and uncoordinated. This is certainly true when she is upset and crying. When she is in a quiet and alert state, though, her movements tend to be smooth and even to have a pattern or rhythm. She is likely to start moving her arms and legs, then slow down and stop, perhaps repeating the process after a minute or two. Although a newborn lacks enough arm control to reach for something with any fluidity, you can catch a glimpse of his capacity for organized motor behavior even at this early stage.

It will be quite a few months before your baby will be able to coordinate her eyes and hands well enough to reach out to grasp a toy. But even at first, when she is quietly gazing at an object, she may extend her arm toward it and reach with her hand. Your baby may even reach toward your face while moving in rhythm with your voice, or she may touch your breast during feeding with coordinated hand and suckling movements. True reaching does not begin until around four months of age, when your baby will begin to reach for objects voluntarily, using more fluid motions to attain the desired target.

Everything your baby does conveys meaning. At times, even her very early hand and arm movements may be intentional. In these cases, her intention will be unmistakable—as when she reaches out to touch your face with her tiny open hand.

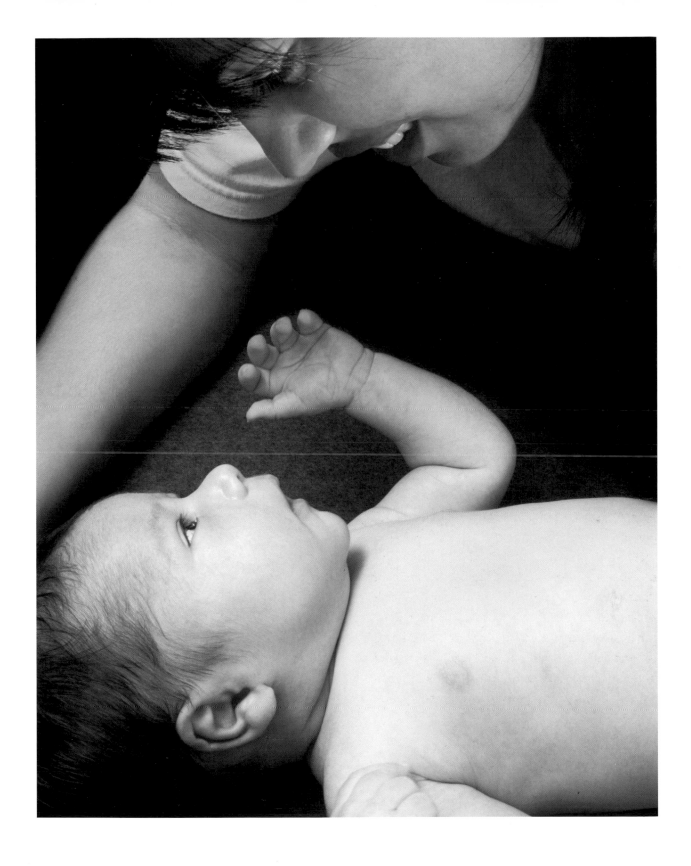

The Smile of Discovery

BABIES IN ALL CULTURES begin to smile between four and eight weeks of age. Even babies who are born blind smile in response to being touched or spoken to around this age. But any time between the first week of life and the third or fourth week, a baby may smile while awake. These first smiles—often called simple smiles—are not the same as social smiles, but they are true signs of arousal and recognition.

Newborn infants seem to pay special attention to faces, so it is not surprising that you are likely to see your baby's first awake smiles as she looks at you. In these smiles, her eyes are wide open, her mouth is open, and the corners of her mouth are pulled back in an expression we immediately recognize as a smile. The first simple smiles usually appear as part of a sequence. Your baby looks at your face, then knits her brow while fixating on it. Then her brow relaxes and the smile appears, as if she now recognizes you. Her simple smile may not be as sustained as a social smile, but it is a true expression of discovery and enjoyment nevertheless.

What do your baby's first smiles mean? They may be the result of tension she experiences as she tries to interpret what she is seeing. At this stage she is beginning to form a model of your face in her developing cortex and is now trying to match the face before her with that vague internal model. The effort she is putting into this task is the source of tension, but her success in matching the face to the model leads to a reduction of tension, then relaxation, and then that fleeting smile. It seems to be a "That *is* you" sign of recognition. "*Now* I recognize that face, that expression." This is a magical learning moment for your baby. Her smile conveys pleasure and satisfaction. That it is your face that has mediated this learning experience makes it a profound moment for both of you.

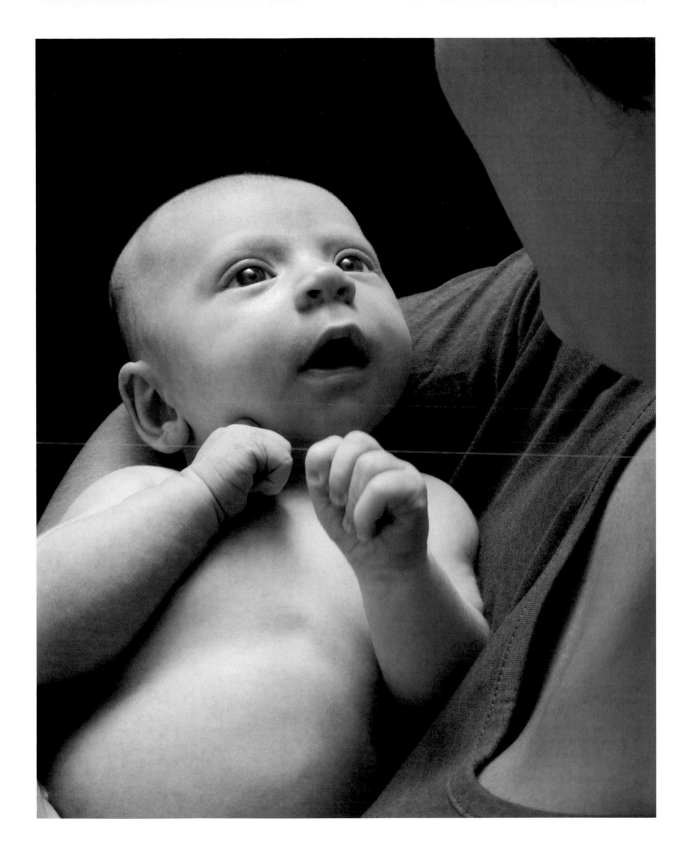

Crawling

Your baby will not be ready to crawl until he is about nine or ten months old. First he has to gain control of his head and shoulders and then his arms, and finally he needs to build up strength in his leg muscles so that he can crawl and eventually walk. Not until motor circuits in the brain mature, and the bones, joints, and ligaments are strong enough to support and actively propel your baby into all corners of his newly found world can true voluntary crawling emerge.

But a baby is born with a "crawl response" that prompts arm and leg movements. Activity in the womb has already begun to strengthen your baby's muscles and to refine the motor circuits. Some researchers believe that the crawl response aids the baby during labor and delivery, enabling him to participate in the birth process by using his legs to push. Remarkably, when a newborn is placed on his mother's stomach immediately after birth, he may try to crawl to the breast to start nursing.

When placed on his abdomen, your baby may begin to flex his arms and legs, lifting his head up and then using his knees to push himself forward. Because the crawl response frees up his airways, al-lowing him to breathe in and out freely, this response also seems designed to protect him from asphyxiation when he is lying face down.

The present widespread practice of placing infants on their backs to sleep has been associated with a dramatic decline in the incidence of sudden infant death syndrome (SIDS). Babies are safest when placed on their backs to sleep. But being placed in this position at all times tends to restrict their movements; babies also need some time on their stomachs so that they can flex their arms and legs. When your baby is awake and you are with him, placing him on his tummy enables him to exercise these motor skills.

Even at this early stage of development, you will need to learn how to maintain the delicate balance between ensuring your baby's safety and at the same time allowing him the freedom to experience his new environment and to build up feelings of competence and mastery. Placing him on his back for sleep and allowing him to be on his stomach while he is awake and while you are with him will meet his need for safety and security as well as his need for freedom and exploration.

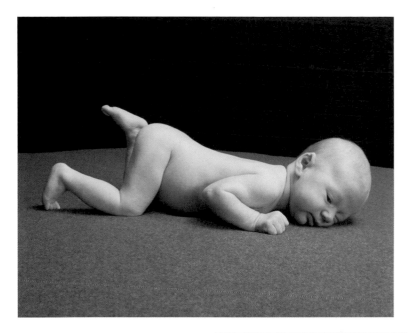

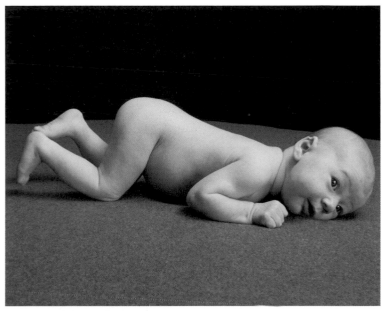

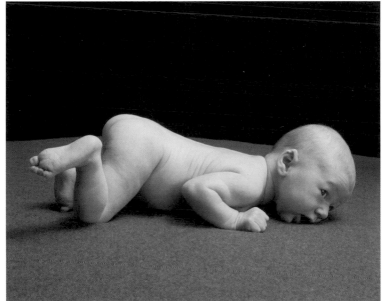

Feet

WHEN YOU LOOK at your newborn, you are likely to look at his face and upper body for signs of contentment or distress. But a close look at his legs and feet can be equally revealing.

When you place your thumb against the sole of your baby's foot just below the toes, you will notice that his toes flex in a grasping movement, much the way his fingers will automatically flex around your finger when you place it on his palm. At other times, it is not your thumb but rather the touch of his other foot that seems to elicit the baby's foot grasp.

At first glance, you may think your baby's crossed feet are no more than a chance configuration. But this is not a random, momentary posture —he will often remain in this position for quite a long time. What you are seeing is another remarkable example of your baby's capacity to regulate his own behavior. This foot clasping or foot bracing enables him to use one leg as a boundary, to inhibit his random leg movements, and to help him stay in a relaxed state.

This is one of the many self-organizing behaviors you may observe as your baby tries to develop motor control in his early weeks and months. Foot clasping is a beautifully reassuring signal that your baby is at ease and capable of regulating his own behavior.

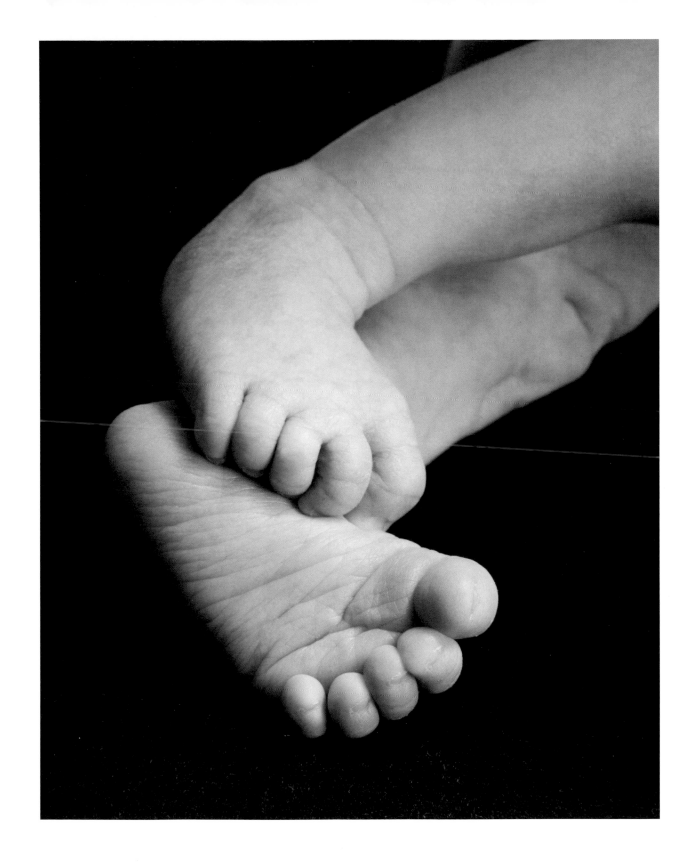

Yawning

Your baby has been stretching and yawning from about her twelfth week in utero. What causes babies to yawn, and why is this baby yawning? Like the rest of us, she may be yawning to stay alert and stave off sleep. Her little body needs considerable oxygen, and yawning provides an added supply to her lungs. Yawning distributes a surfactant, a gelatinous liquid that coats the tiny air pockets in her small lungs and helps keep them open. Babies need an adequate amount of surfactant to breathe and survive outside the womb. So the newborn yawn is important to her survival.

In this case, the yawn has another, more subtle meaning. This yawn took place in the middle of a "conversation" between baby and mother. She is not bored or sleepy; the yawn is her nonverbal way of saying that as much as she is enjoying this interaction with her mother, it has become too demanding. This yawn is a "time-out" cue.

You may find that when you and your baby are looking into each other's eyes, "talking to each other," he may yawn. Because yawning is associated with a stretching of the muscles and joints and a faster heart rate, it is his body's way of saying that he needs to pause so he can renew his energy before continuing to play with you. By opening his mouth wide and closing his eyes, he can no longer look into your eyes, and you can't see his. By simply turning away, your baby is taking the lead in regulating your time together, dictating the pace and rhythm of the interaction between you.

These moments of exchange are filled with pleasure for you and your baby, but taking turns and maintaining full eye contact is hard work for your baby's growing brain. He uses nonverbal communication strategies, such as yawning, to indicate his need to disengage from the intensity of the interaction. By learning to read and respond to such signals, you can get to know your baby better so that the bond between you can continue to grow and develop.

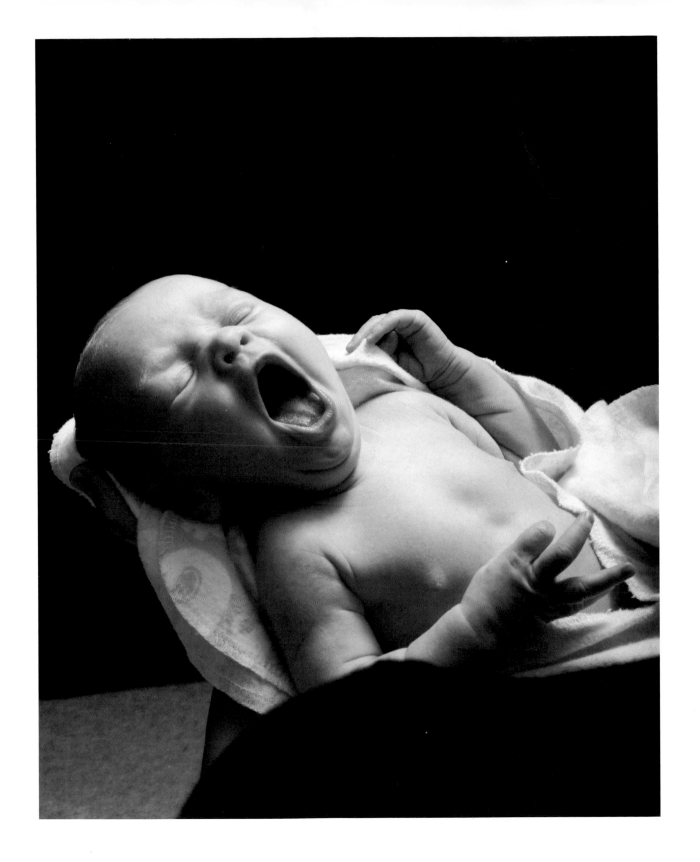

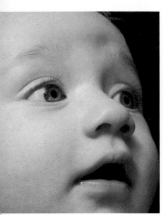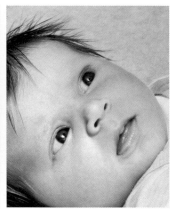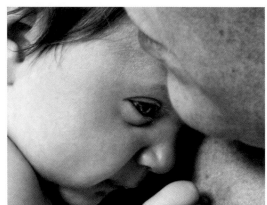

Your Baby's Senses

Responding to Sounds

Not very long ago it was believed, even in certain medical circles, that the fluid in a newborn's ears impaired hearing for at least the first few days of life. But mothers knew better, insisting that their babies could not only hear but were able to recognize their voices from the very beginning. We now know that mothers were right all along. In fact, the neural structures underlying hearing develop early in utero, and by the end of the third trimester, the baby's ability to distinguish the full range of frequencies is almost completely developed. Indeed, all the main anatomical features within the cochlea, which determine the ears' responses to different frequencies, are essentially adultlike at birth.

From your baby's earliest days, you will see him respond to the sounds of his new world. The soft sound of a baby rattle may cause him to be still and his eyes to grow bright. He will then begin a slow search for the source of the sound and will not stop until he finds it. You can see the sense of discovery reflected in his eyes. Your newborn seems programmed to explore the sounds in his environment from the start. His innate sense of curiosity fuels his efforts, and his well-developed capacity to hear low-frequency sounds helps him reach that goal.

Even more amazing than a newborn's ability to turn toward and locate a sound is his capacity to detect a rhythmic beat. Perhaps because it promises repetition and continuity, rhythm provides a reassuring aural ambience for the newborn. This may be why your baby is comforted by the soothing sounds of a lullaby and by the soft, familiar rhythms of your voice. Along with vision and touch, hearing is one of your baby's primary avenues for learning, through which he will experience language and music, basic aspects of his intellectual and emotional development now and for the rest of his life.

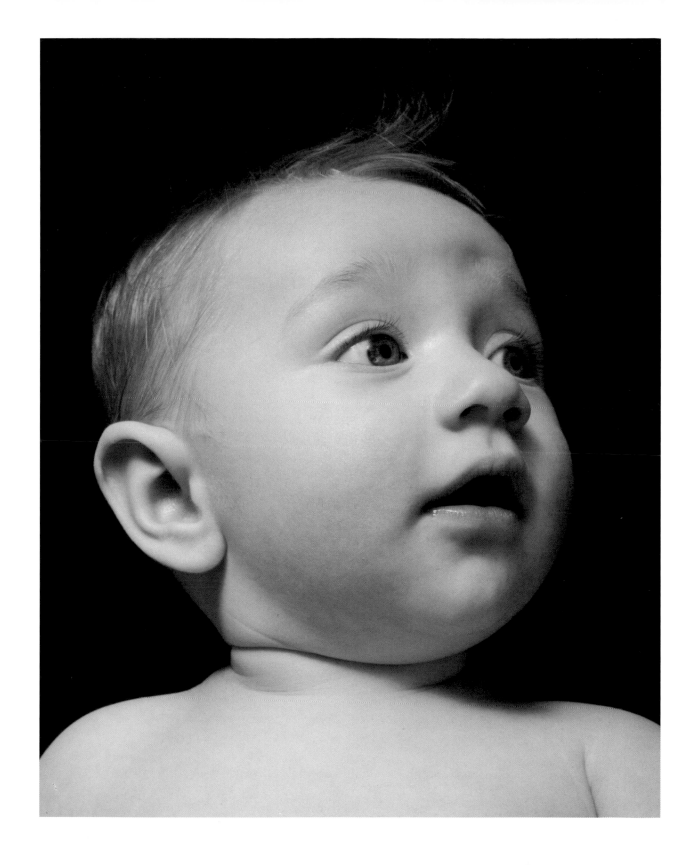

Visual Exploration

THERE WAS A TIME not so long ago when people believed that newborns could not see or could see only vague shadows. We know now that visual development begins in the fourth week of embryonic life, with the initial formation of the eye. This means that while your new baby does not have the 20/20 visual acuity of an adult, she can see quite well at close range, where most everything that is of interest to her happens. She can focus best on objects in front of her and twelve to eighteen inches away.

While newborn babies show a visual preference for faces over objects, they can see colored and black-and-white patterns that are not too small and have plenty of contrast. Infants' color vision is not likely to be as rich and sensitive as that of adults, but your newborn can distinguish a red object from a green one even when these are perfectly matched in brightness. She will prefer bold colors to soft pastel colors, and by about two months of age will be able to focus clear images onto her retina.

This one-day-old baby girl is looking at something she has never seen before—a bright red ball. Her slightly raised brows and closed mouth all convey an expression of sustained visual attention and concentration. She seems to be taking it in! She begins to track the ball as it moves, looking steadily and intently. Her breathing slows and her heart rate decreases, indicating positive emotional excitement—characteristics of a state of attentiveness. She continues to track the ball until she is no longer interested, and only then does she turn away. But she has already learned something new, and as a result, on this first day of her life, the structure of her brain has been changed forever.

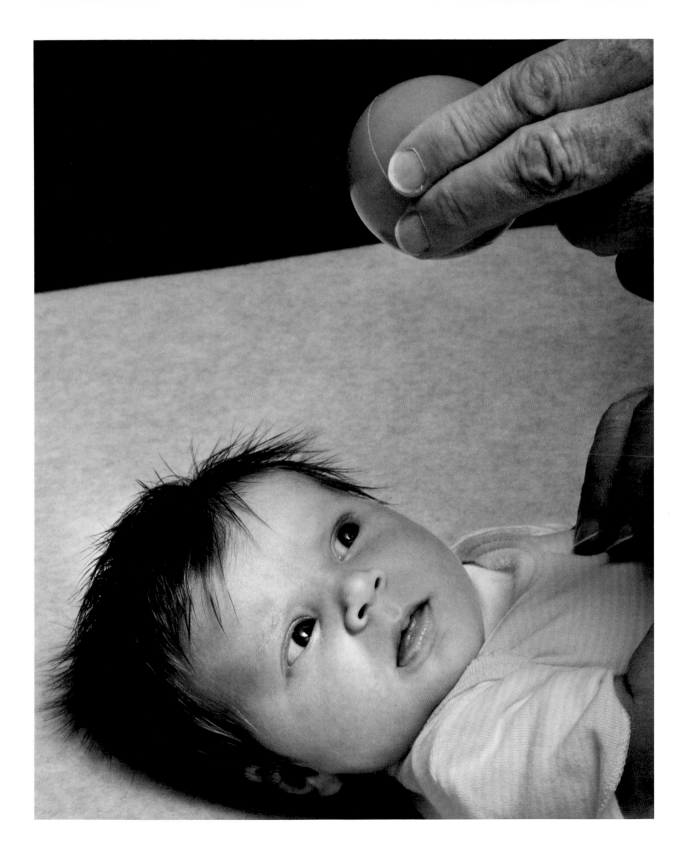

Touch

THE NEWBORN BABY experiences her new world through her eyes, her ears, her nose, her taste buds, and her sense of touch, which is the most highly developed of the senses at birth. This should not surprise us, as we have already seen that touch is the first sense to develop in utero. The sensory cortex, where touch is consciously perceived, is the most developed area of the brain at birth.

This may be why infant massage, which involves gentle stroking of the entire body, has been found to improve a newborn's sleep organization, lower the level of cortisol (the primary stress hormone), and help the baby gain weight. Skin-to-skin contact, sometimes called "kangaroo care," helps preterm infants regulate their temperature, improves their overall weight gain, and also promotes positive interactions between mother and baby.

Since newborns are sensitive to touch, they also feel pain, especially pain caused by contact with the skin. In fact, neural pathways for pain are present in the fetus by about twenty-six weeks after conception. In the past, people thought that newborns might not really feel pain. But if you have watched your baby's reaction to a heel stick to collect a blood sample and have seen her grimace and heard her piercing cry, you understand how strongly babies react to pain. Holding, stroking, swaddling, putting your baby to breast, comforting, or talking to her can reduce her experience of pain and even modify her overall sensitivity to it.

Your caring touch plays a critical role in the development of your relationship with your baby, because through touch you can communicate love, sympathy, and a sense of security. Being held and cuddled, being rocked to sleep, being patted or stroked to reduce distress—all these comforting touches have positive, even critical, effects on your baby's physical and emotional development.

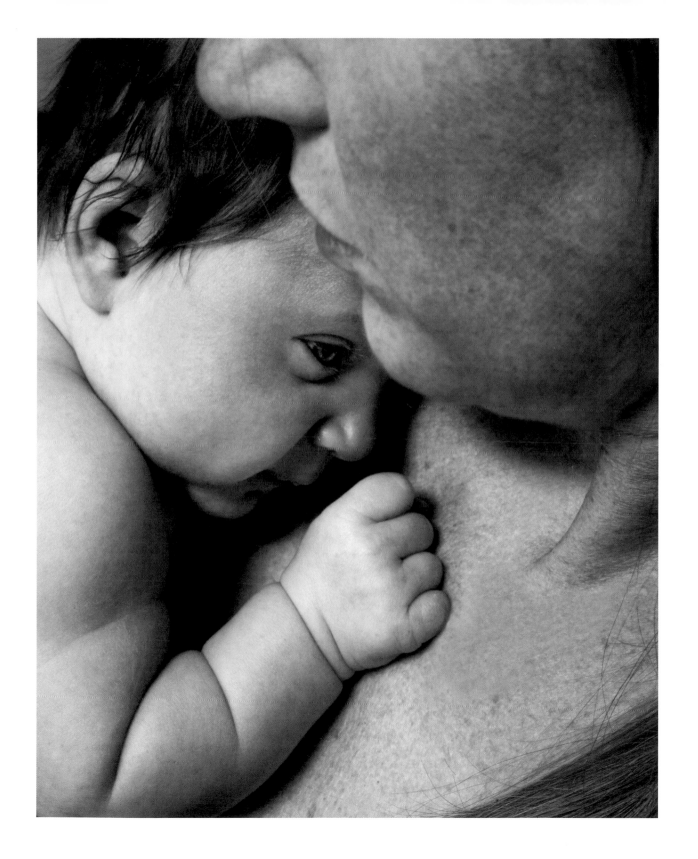

Cuddliness

DURING PREGNANCY, ALL parents fantasize about how their babies will look and act. The idealized baby of pregnancy has big eyes, dimpled cheeks, and a firm, smooth body clothed in silky skin—a baby, who, when she is picked up, will immediately nestle into the soft slope of her mother's or father's neck.

Many babies—perhaps yours is one—relax into the cocoon of your enfolded arms from the moment they are born, as if nature had ordained it so, as if babies were just naturally cuddly. A cuddly baby fills parents with feelings of deep tenderness. It is hard to resist touching and exploring the baby's little body, which seems only to enhance his responsiveness.

For both the father and the mother, touching and holding their baby close stimulates a release of oxytocin in the endocrine system, which fills the parent with feelings of deep tenderness and allows relaxation into an even longer cuddle. The physical contact initiates a reinforcing cycle. The increase in oxytocin intensifies the amount of physical contact, and this in turn releases more oxytocin. This baby-parent feedback system may be why oxytocin is often referred to as the "bonding hormone" or "love hormone."

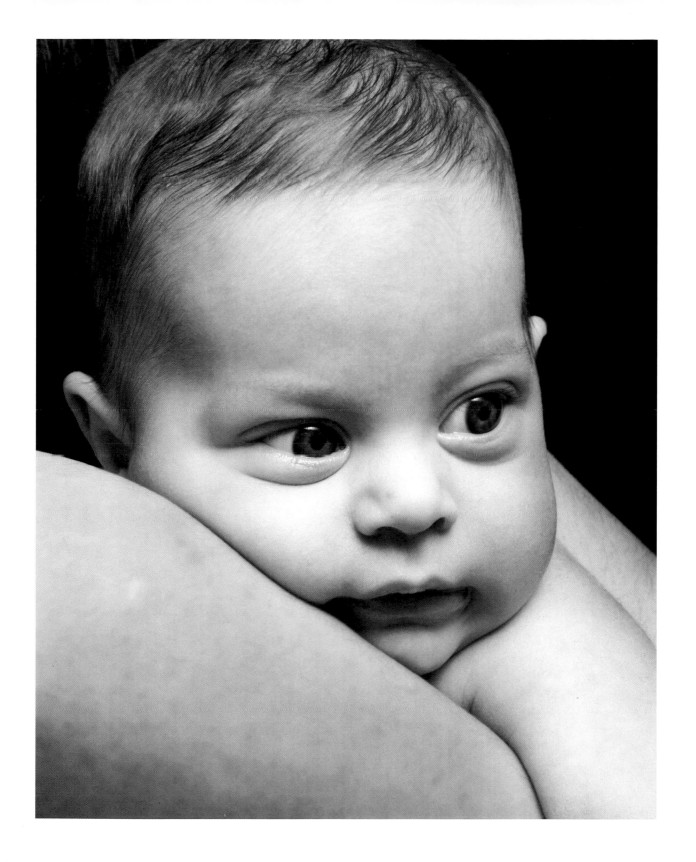

The Not Very Cuddly Baby

NOT ALL BABIES are cuddly. Their small bodies are by nature rigid and so sensitive to touch that they seem to recoil from their parents' efforts to hold them close. Rather than mold into the soft slope of the mother's or father's neck, these babies resist being held or even touched, almost as if they are rejecting their parents.

At least that is how parents see it. For many mothers and fathers, the dream of having a baby who instinctively nestles against them may not be realized—at least not in the way they had imagined. This is crushing for any new parent, because all expectant parents imagine that their tiny helpless baby will respond to their every caress from the moment he is born. Parents may come to believe that their baby is literally pushing them away or even that their baby does not love them.

If your baby is like this, it may be reassuring to know that a great many newborns are not cuddly. This may simply be part of the baby's physiological makeup or temperament; there is no evidence that it is an expression of rejection. Your baby's behavioral style does not have any bearing on his feelings for you, nor is it a result of the way you are parent-

ing. It's also important to remember that a not very cuddly baby will learn and develop just as well as one who is cuddly.

So if your new baby does not naturally mold her body to yours and if she feels stiff and rigid despite your best efforts to cuddle her, you need to recognize that this is simply how she is. She may or may not change over time. But she can respond to you in other ways that are just as reliable and fulfilling as cuddling. You may find, for example, that your baby is at her best when she is holding herself upright, looking out over your shoulder, visually exploring her surroundings. As time goes by, you will be able to find ways to share physical contact that suit her disposition and style. But first you may have to let go of the "fantasy baby" of your dreams and come to accept and enjoy your baby as she is in all her exquisite uniqueness.

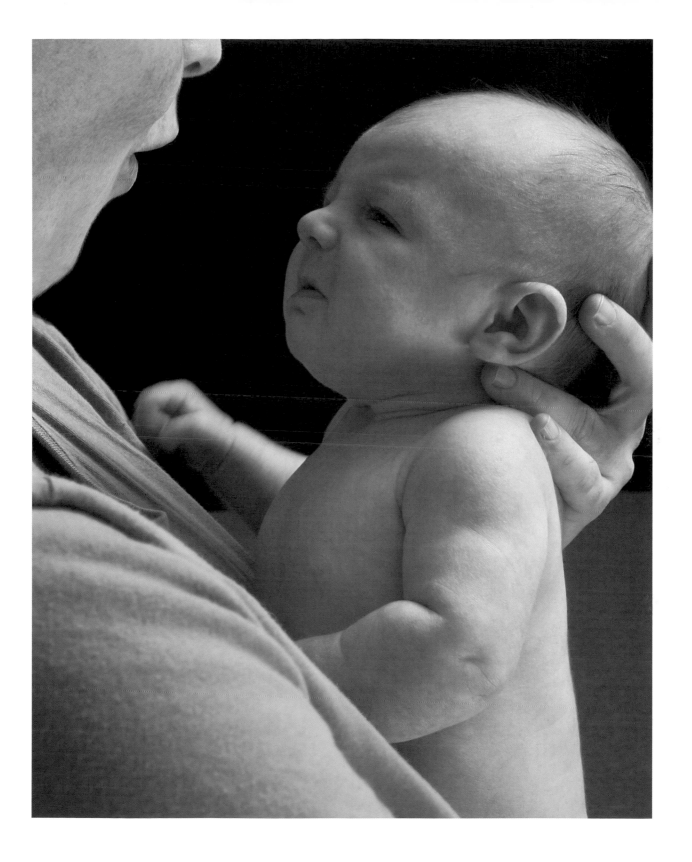

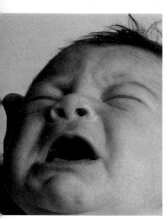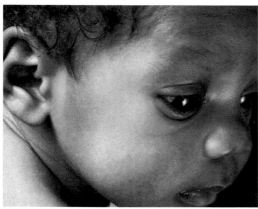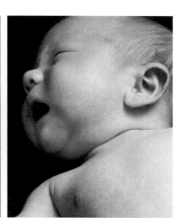

Settling In

Startles

ALL BABIES STARTLE. But new parents are shocked when they see such a massive response in a small baby—the sudden extension of the arms, the arched back, the rigid arms and legs, the tightened fingers. The baby's eyes have an expression of something like panic, as if he senses a loss of support and feels that he is falling. He seems to be frantically trying to protect himself by grabbing something with his open hands.

The startle response occurs even in the early stages of pregnancy, as the fetus responds to loud sounds with a dramatic movement of the whole body. By the last trimester, the response may be triggered by the mother suddenly shifting her position in bed, for example. There is a theory that startles are common in newborns because the baby is accustomed to the more cushioned protection of the amniotic fluid.

Startles seem to be set off when your baby's senses receive excessive information. A bright flash of light, a loud noise, a sudden touch, or any unexpected stimulation of the baby's balance system, such as suddenly changing his position or tilting him, may activate the startle response. You will probably see this response many times, because loud noises and surprises are unavoidable in any household. Still, some babies are more sensitive than others and thus more easily startled. If you are the parent of an especially sensitive baby, it is best to avoid noisy or brightly lit places and other experiences that are likely to shock your baby's system.

But, as stressful as the startle appears, it is actually a sign of the maturity of your baby's central nervous system and thus a sign of his health and well-being. And despite the shock your baby experiences, no sooner has it happened than it is over. He stops crying, his arms lose their rigidity, and he resumes the relaxed fencer posture we see here. He is now fully recovered.

Still, all babies—especially those with a low threshold for startles—appreciate being cuddled and reassured after a major startle. You will discover that your own momentary panic when first seeing your baby startle will be followed by a sigh of relief as he shows you that he is not as "breakable" as you imagined.

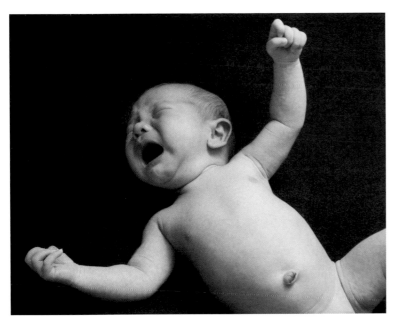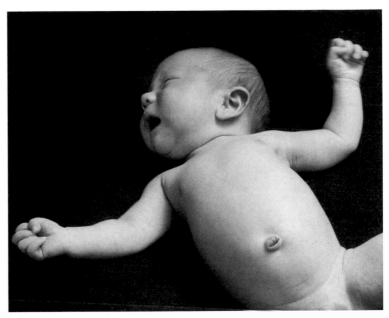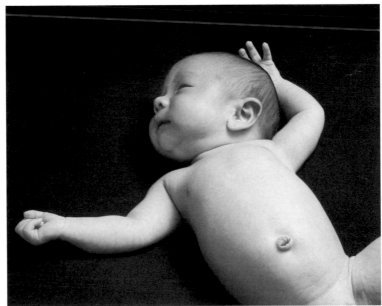

Drowsiness

THIS BABY IS in a liminal state, a no man's land between sleep and wakefulness. Her half-open, half-closed eyelids are droopy, her overall expression unfocused and diffuse. She does not seem to be looking at anyone or anything in particular. If she does open both eyes, it will be for only a few seconds. This baby is clearly in transition, as if undecided about whether to come out to take a look at her inviting new world or remain in the reassuring calm of her comfortable, protective sleep. When your baby is in this state, she is telling you to wait for her next communication cue. She may be saying, "Give me time. I need to be wide awake before I can begin to enjoy feeding and looking at you."

While some babies' behavioral patterns are clear and predictable from the beginning, many babies need time to develop robust sleep-wake patterns. You can best help your baby achieve this goal by respecting her efforts and not disturbing her in a transition state—even if you really want to wake her up for feeding or play. It is often very difficult for parents to restrain the urge to wake their baby, but keep in mind that developing her own sleep-wake pattern is one of her most important tasks. And that pattern may be as much a matter of temperament and individual physiology as of your response to her.

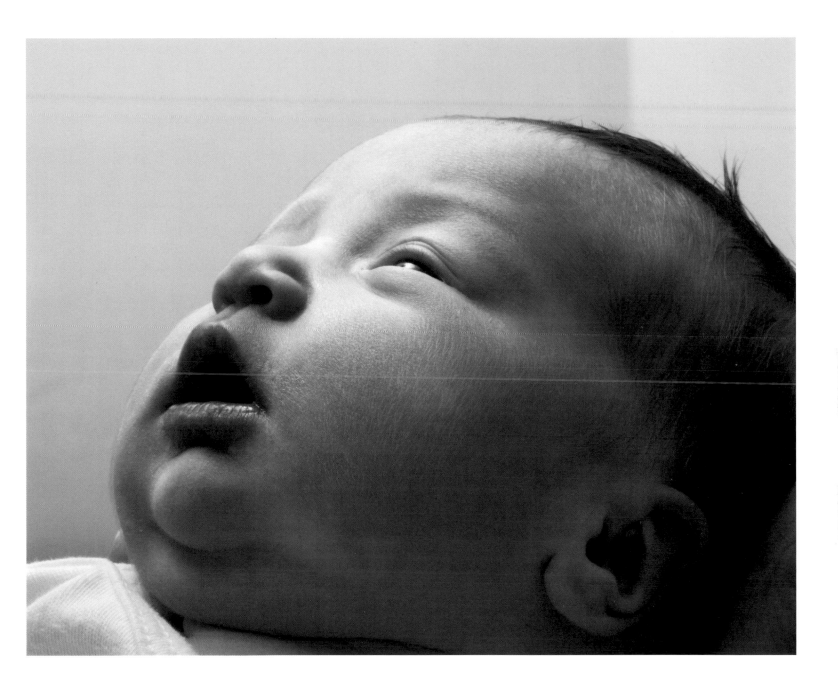

Overstimulation

At first glance you might mistake an expression of overstimulation for a look of intense interest, even surprise, but the slight turning away of the head, the arched eyebrows, and the too-wide eyes convey a different message. When your baby takes on this expression, it is a sign that he is overstimulated and struggling to stay focused on what he is doing. This may happen if he is trying to take in an overly exciting experience such as a toy that keeps blinking and beeping or even a too-loud face-to-face exchange. When a stimulus becomes too intrusive or demanding, he feels unable to break away from it or protect himself. This little boy's wide-eyed stare was a response to an overly intense face-to-face interaction with his mother. Although there is a wide range of individual differences in how babies respond and adapt to stimulation, too much excitement can overwhelm and exhaust your baby and compromise his ability to maintain stable periods of social availability.

As he moves from the newborn period into the third month of life, your baby will enjoy face-to-face interaction with you more than anything else. So it can come as a surprise when he shows signs of be-

ing distressed in the course of play. He may become wide-eyed and fixated, or he may turn away and avert his gaze, as if to avoid you. Both reactions are subtle, elegant behavioral cues in your nonverbal baby's repertoire when faced with an overstimulating experience. At such times, he may need you to protect him by lowering the level and flow of information and stimulation that he is being exposed to.

Every one of your baby's signals and behavioral cues has communicative value, and each one will help as you try to understand his behavior. During the first weeks and months, you and your baby will have many opportunities together to find interactional patterns and rhythms that match your individual styles and temperaments. This is what will give your interaction a unique signature.

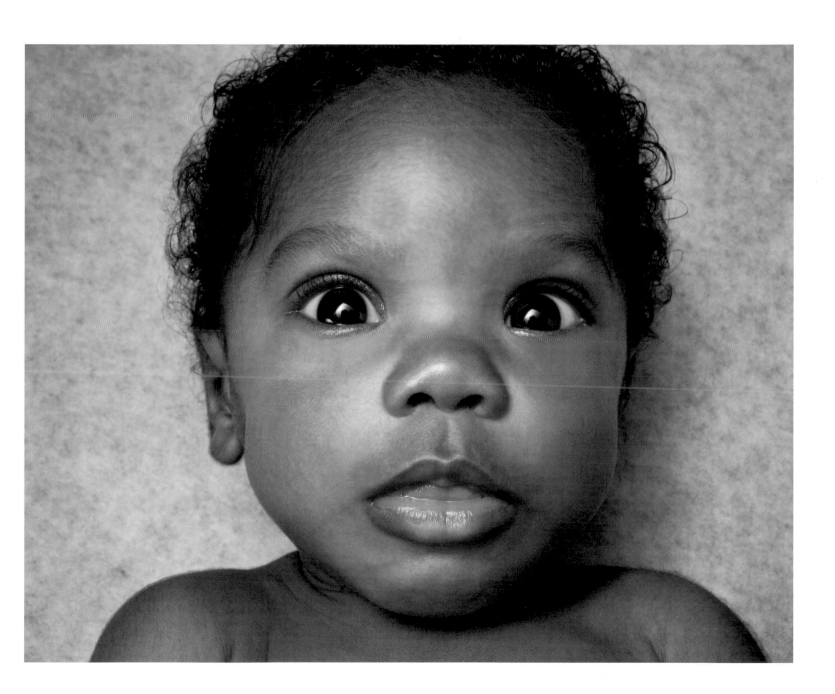

Signs of Distress

Babies clearly are interested in exploring their new surroundings outside the womb—but there are limits to the amount of stimulation they can tolerate and enjoy. And babies differ greatly in their ability to cope with different kinds of stimulation. Some babies can tolerate and even thrive on high levels of stimulation. Others are less tolerant but simply need time-outs or breaks from interacting with the environment before continuing. Still other babies are easily overwhelmed, even becoming exhausted in the face of continuous stimulation.

All babies show signs of distress at one time or another. If your baby's skin becomes pale, dusky, very red, or blotchy, it is a clear indication of stress. Uneven breathing may also be a sign of stress, a signal that your baby needs your help to modulate her behavior. You may feel her whole body suddenly become rigid, with her fingers splaying or in a tight fist and her legs rigidly extended. Startles, twitches, and tremors are reliable stress signals, while gagging, spitting up, coughing, sighing, sneezing, hiccupping, and yawning are other signs she may use to tell you that she is distressed, overwhelmed, or even exhausted. You may detect more subtle be-havioral cues, such as frowning, furrowing of the brow, or mouthing and tongue extension. Some babies react to overstimulation by becoming much less alert—shutting down, in a way. The baby's eyes become drowsy, he shows little movement, and his body becomes flaccid and limp.

These signs are designed to get your attention. You may miss many of them at first, but as you get to know your baby and learn to identify and respond to her distress cues, you will be helping her develop control over her environment. This kind of individualized support will enable your baby to cope with the unpredictable, overstimulating, and uncertain events that are commonplace in her new world.

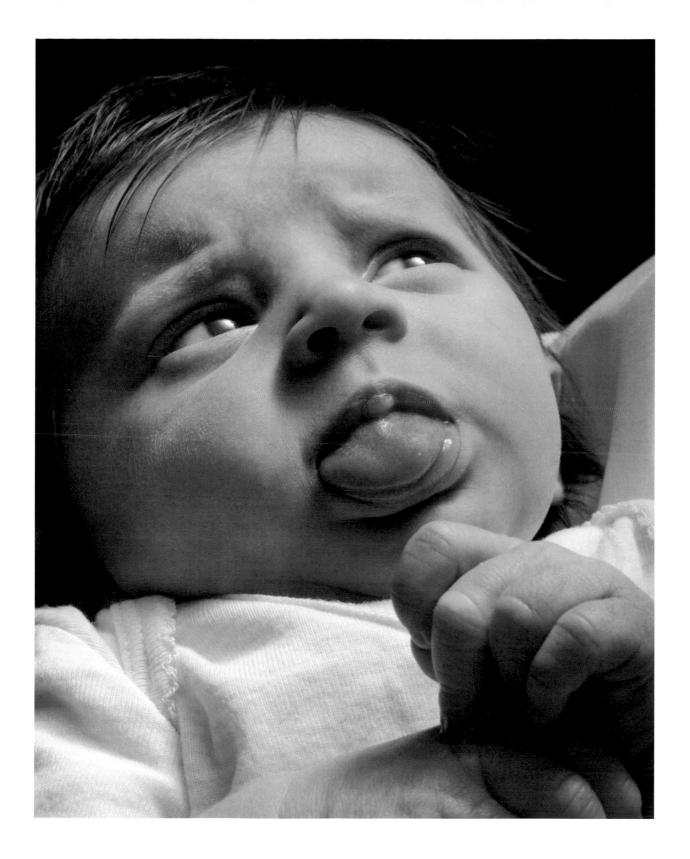

Soothability

MOST BABIES REQUIRE some kind of soothing stimulation when they cry. Some may be able to settle themselves when left alone by readjusting their posture or by sucking on their hands. But most babies need help to settle. A calm, sympathetic tone of voice or a soft lullaby, a touch on the arm, gentle rocking, or being patted and drawn into the immediate physical comfort of your arms—any of these techniques may help a baby recover and settle. But some babies are very difficult to soothe, and none of these classic approaches seem to work with them. Whether your baby is easy or difficult to soothe, your attempts to find the consoling strategies that work best for your baby's temperament or style are likely to consume the early days and weeks of your newborn's life.

In many cultures, mothers respond to crying simply by breastfeeding. This is a natural response, because when you hear your baby cry, the blood flow to your breast increases, instigating a biological urge to nurse. The act of breastfeeding itself causes a surge of prolactin, the hormone that causes your milk to let down, which, along with the release of oxytocin, brings feelings of relief and pleasure to both you and your baby.

Fortunately, in finding the most effective consoling techniques, your baby will be your guide. He will tell you what works for him, whether it is nursing, talking to him, swaddling or gently rocking, walking with him, or holding him on your shoulder. But knowing why your baby is crying will make it easier to find the consoling techniques that work. A hunger cry and a pain cry call for very different responses. Anticipating your baby's cry by learning her early warning signals of overload or overstimulation can help shorten the crying period. Whatever the reason for the crying, responding to your baby's cries with warmth and consistency builds up his feeling of trust, his very sense of self. In these small, unremembered acts of love, your baby senses in a profound way that he is safe and that he is loved.

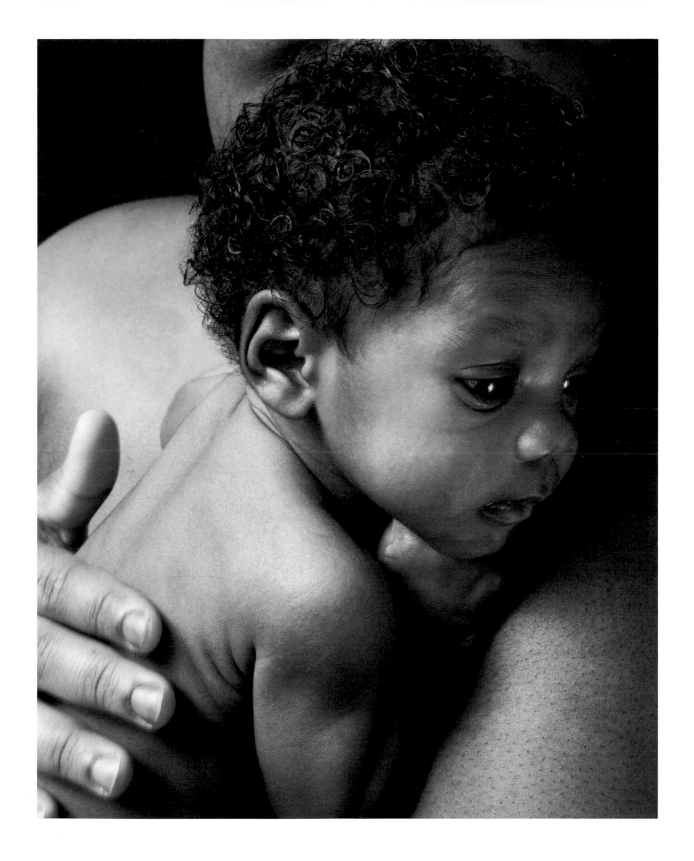

The Not Easily Settled Baby

CARING FOR A BABY who cries a lot is extremely stressful. Many parents feel disheartened, even overwhelmed, by their baby's continuous and sometimes inconsolable crying. They may find that none of the usual calming techniques work. Continuous and excessive crying can create tension among family members and affect the way they behave with one another.

Persistent crying for no obvious reason, which occurs in every culture, is especially stressful because it is so difficult to identify the cause and so hard to soothe the baby. Although the causes of inconsolable crying are not fully understood, it may be that the baby is feeling pain or discomfort brought on by some transient bodily, gastrointestinal, or environmental condition. Or it may be that your baby has an extremely sensitive temperament. It may help to remember that excessive crying in the early months is usually a transient phenomenon and will have no effect on your child's later adjustment.

Even when parents respond with sensitive care, babies may have prolonged bouts of fussing and inconsolable crying. Discovering the most effective consoling techniques for your baby takes devotion and commitment. You may want to check with your pediatrician, if only to set your mind at ease that your baby's overall health is fine. What will help you the most is support from others, and even some respite time from caregiving. Experienced parents will reassure you that in a very short time your baby's inconsolable crying will be greatly reduced, and you and your baby will be ready to enjoy playing and interacting with each other once again.

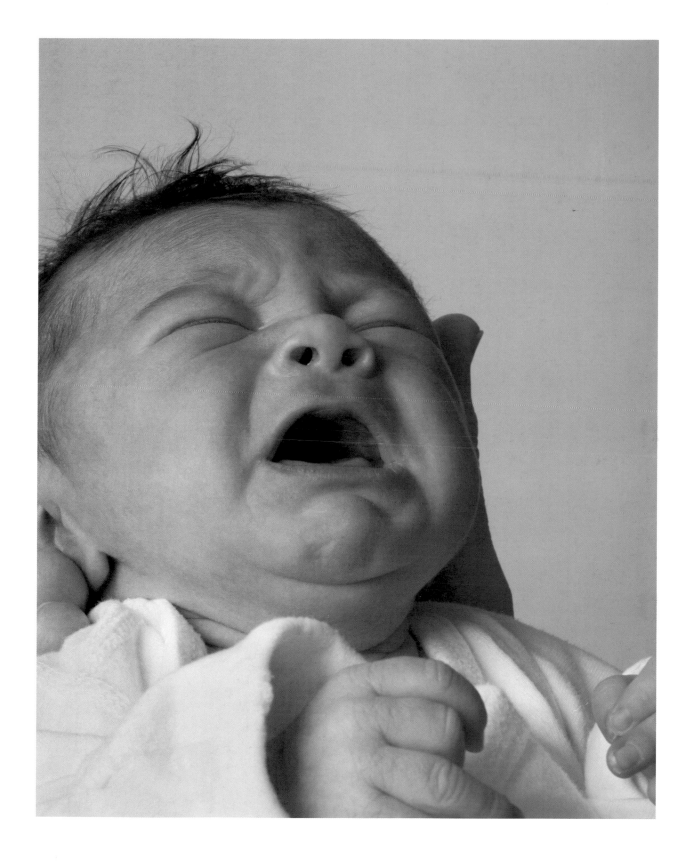

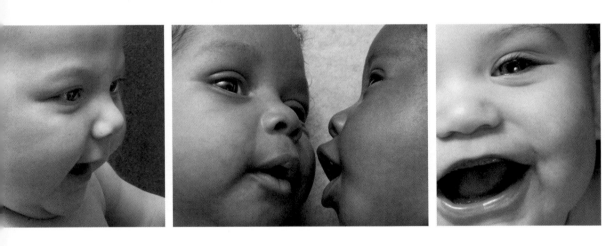

The Social Newborn

Looking into Your Eyes

Even before they are able to speak, very young babies have fairly specialized brain mechanisms that allow them to pick up on nonverbal signals. Your baby has the remarkable capacity to respond to your expressions and to engage in face-to-face, eye-to-eye mutual exchanges—if only for very brief periods—even in the early days and weeks of life. It is as if infants have an inborn capacity for connecting with others and will not be satisfied until they have established a connection with their caregiver. No mother or father will ever forget the first time the new baby looks into their eyes and seems to recognize them.

Sometimes your baby will initiate eye contact himself. He may use different strategies to catch your eye—a brief fuss while he is in his crib or a pause during feeding. At the beginning, these fleeting expressions of feeling may be short, lasting less than a second, but when you catch one you know you have encountered your baby as a person, an individual whom you can now get to know.

As your baby grows and develops, these moments of opportunity become more frequent and last longer. You will be thrillingly aware that as your baby looks directly into your eyes, his expression shows emotional investment. He is much more engaged and expectant than he is when looking at a mobile, even one that is very interesting to him. You can see his eyes begin to narrow and focus on you, his mouth partially open and lips pursed, all suggesting a high arousal level. Your baby is communicating something essential—that he is here and ready to engage in face-to-face play with you, the center of his social world.

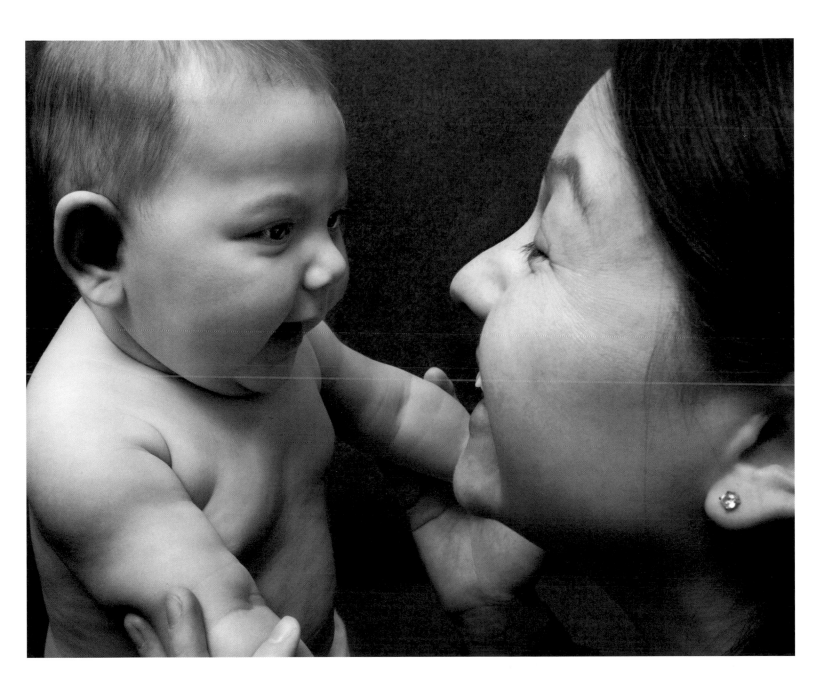

Feeding and Communication

FEEDING CAN BE a time of exquisite intimacy and intense pleasure for both you and your baby. This is the highest level of tactile stimulation your baby can experience. As she lies in your arms, you can feel the strong rhythmic sucking movements reverberate through your body. You may even see her ears move as she sucks, so intent is she on succeeding at her task. Her hand may be on your skin or holding on to your finger—a perfect anchor of support for maintaining her feeding position. If you are bottle-feeding, you can also enjoy this form of skin-on-skin physical contact, which leads to the release of oxytocin in the brain and strengthens the bond between you and your baby.

The close position of a mother and her nursing baby is perfect for enhancing the interactions between you. The distance from the baby's position at the breast to your eyes is the ideal visual range for a newborn—nature's perfect synchrony.

You will see that after a burst of vigorous sucking, your baby may pause and raise her eyes to look up at you before she returns to feeding. During this momentary pause—a micro-moment really—baby and parent can exchange fleeting but deeply meaningful expressions of emotional feeling for each other. The communication cues are clear and direct. Your baby is receiving the nutrition she needs for her very survival while basking in the loving care and security you are offering, which are equally essential for her growth and emotional development.

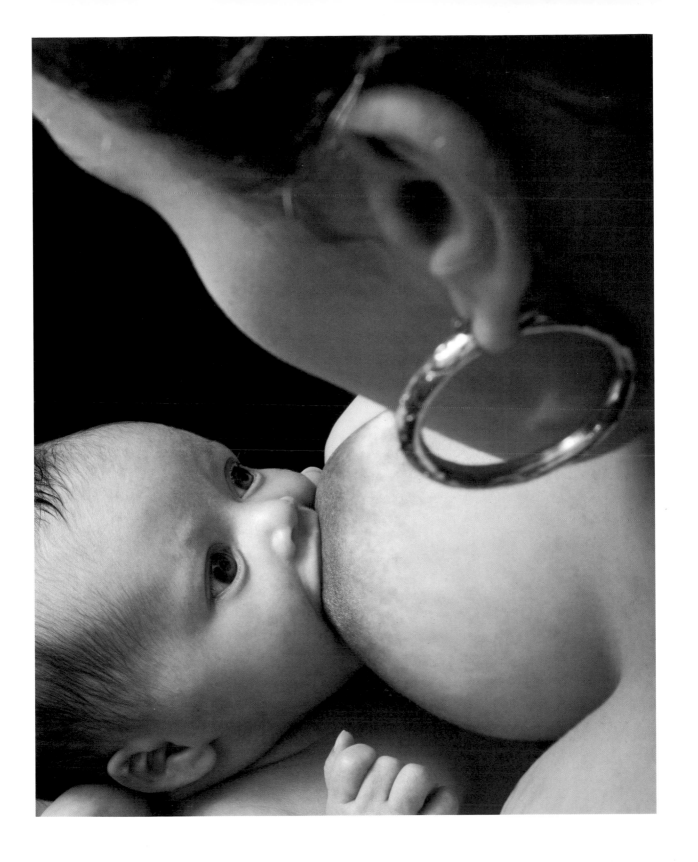

The Power of Your Voice

Although you might think of the womb as a place of silence, external sounds do reach the unborn baby—music, for instance, and especially the high-pitched singsong of a mother's voice. We know that babies in utero can hear and respond to speech sounds because we can observe their heart rate slowing down—a sign of interest and attention. Soon after a baby is born, she is already so accustomed to the sound of her mother's voice in particular that she can discriminate it from the voice of a stranger. And soon after that, she can even tell the difference between some sound patterns, such as "ba" and "ga," "ma" and "na," and even between "*ma*-ma" and "ma-*ma*."

A newborn baby prefers her mother's or father's voice to any other sound. Holding your newborn baby about ten to eighteen inches from your face and talking in a soft voice may be the ideal stimulus for her. It is the perfect way for the two of you to begin to interact and communicate. Obviously, your baby cannot understand your words, but she can detect the overall patterns of rhythm and pitch that differentiate your voice from anyone else's. It is the warm emotional tone of your voice that draws and captivates her. This is what she will remember above all else.

As you look into your baby's eyes and begin to talk to her, you may find yourself spontaneously using a special style of speaking. The pitch of your voice naturally rises, and you are likely to speak in tone sequences lasting from five to fifteen seconds. This slower, higher-pitched, more melodic and repetitive "infant-directed speech" makes it more likely that you will engage your baby's attention and makes it easier for her to understand your emotional intentions. Although eye contact plays a central role in promoting parent-infant interaction and in establishing the bond between you and your baby, it is her sense of hearing that may permit the fullest communication during her very earliest days.

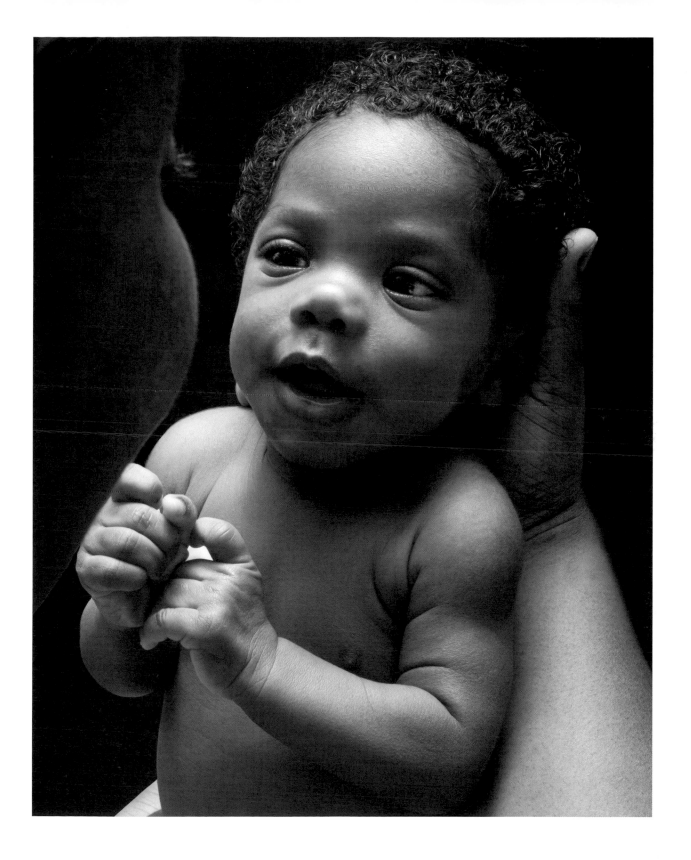

Imitation

AMAZINGLY, YOUR NEWBORN can imitate facial expressions. This is almost impossible to believe when we consider what is involved in the act of imitation. Your baby must not only be able to see your face, he must match what he sees with an inbuilt knowledge of his own face and then use this match to produce the same expression—which, of course, he cannot see.

Your baby learns mainly by watching and observing, but he also learns and gains an understanding of his physical world and of the psychological world of people by imitating. If you are a new parent, your baby's imitation may stimulate an active cycle of interaction between the two of you. But for imitation to take place, the conditions have to be almost perfect: your baby must be in a quiet alert state, neither hungry nor tired, and the two of you must be face to face. He may begin by imitating your expression and then may spontaneously produce another expression, as if he has anticipated your reaction and has an expectation about how this interaction should proceed.

The capacity to imitate is a powerful learning tool in the baby's repertoire, but it is also an intimate form of face-to-face communication. Although it develops long before your baby speaks his first word, it is the beginning of the back-and-forth conversation that is at the heart of human interaction.

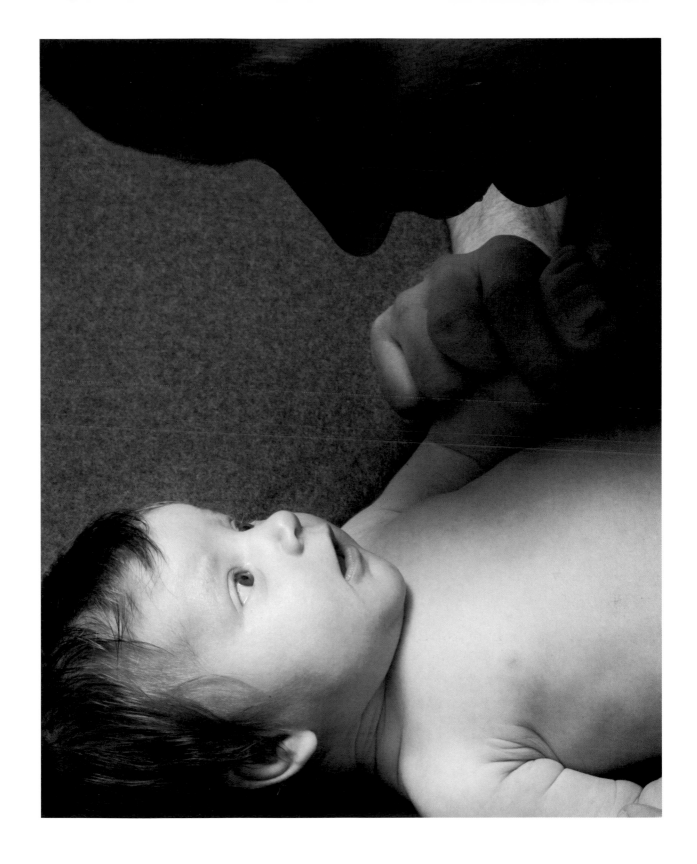

Learning

When, as adults, we experience something new or startling, we become vividly conscious of it. Our attention is riveted, as if we were shining a spotlight on the object or scene. As we explore its characteristics, we become less conscious of what's going on around us. We take in as much information as we can before our interest trails off. As this is happening, our brains are producing characteristic electrical patterns—brain waves—associated with attention. Your newborn is doing the same thing—and he is doing it much more of the time, because everything in his world is new to him.

Your baby's appetite for knowledge seems to be self-propelled and voracious. Countless intricate interactions are taking place inside his brain as a result of his experiences with you and the world around him. During his early weeks and months, your baby has already begun to recognize the contours of your face and to identify the rhythms and cadences of your voice. He associates the breast with the pleasure of feeding, and he may already associate his father's hands and voice with the excitement of play. He is connecting certain smells and touches with feelings of consolation and safety, and when he

hears a sibling's familiar high-pitched voice, he can distinguish it from other voices. Your baby is trying to impose some shape and structure, some kind of constancy, on his world to anchor him in the wide sea of daily experiences.

We know that your baby's brain is shaped by the quality of his early experiences, but we also know that even though he is uniquely dependent on you, you do not have to formally teach him anything at this time. Your baby is learning simply by watching you and by paying attention to all that is new and unexpected in the world around him. However, he is able to learn only because he can rely on you to protect him and meet all his needs. Whether he is asleep, wide awake, or in distress, it is the consistency and reliability of the care you provide that allows him to take in all the information he needs to understand his world. Love makes learning possible, and then learning provides its own momentum. Parents are simply the choreographers.

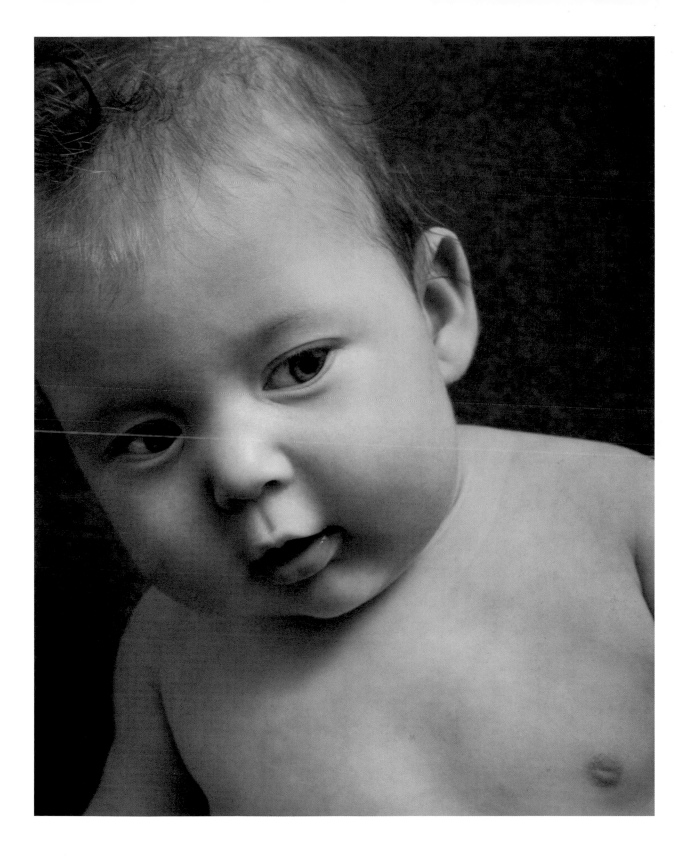

Temperament

EVERY NEWBORN BABY is unique, with a distinctive behavioral repertoire — even these newborn twins. Their very different temperaments and personalities will emerge with greater clarity as they grow, but even now their differences are obvious in the way they move and in their activity levels. One twin is imperturbable and "easygoing," according to the parents, even in the face of his twin's constant attentions. The other one seems to be constantly "on the move," displaying high levels of spontaneous activity.

Your baby may be quiet by nature and able to remain still for long periods of time. His arm and leg movements may be smooth and relaxed, even under a loose covering, and he may have little difficulty remaining quiet and calm during feeding. Or your baby may be more active and want occasional help to settle herself, but she may not need swaddling all the time.

Some babies, however, and perhaps yours is one of them, are almost always in a state of motion. These babies seem to revel in the excitement of their ever-changing new world of faces and voices. This, of course, makes sleeping and feeding diffi-cult both for them and for their parents. If an active baby is placed on her back between feedings, she may keep moving and become frustrated when she cannot settle and calm herself. If your baby tends to display this high activity level, her body movements are telling you that she needs your help to settle. Offering her the containment, physical contact, and security she needs can enable her to have some quiet alert periods so that feeding and play become enjoyable for you both. You may find that tucking her in and placing boundaries around her in the crib will help her restrain her arm and leg movements. When she is ready to feed or interact with you, she may also need to be swaddled and held securely.

Most babies fall somewhere in between the two extremes, with periods of activity and periods of quiet. All babies need to develop control over their motor behavior during the first months of life, and by being alert and sensitive to your own baby's unique style you can give her the most profound support.

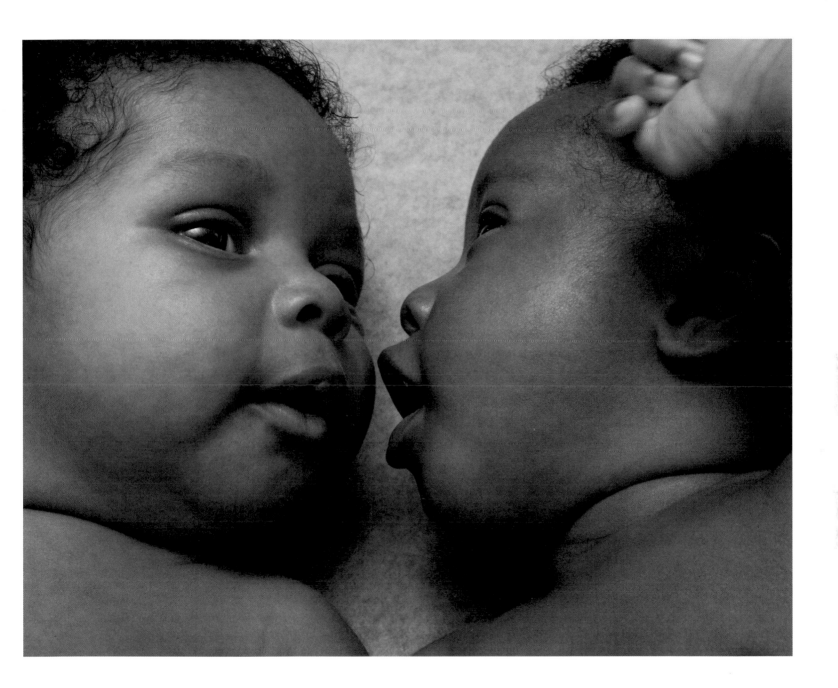

The Social Smile

As adults, we know that being able to read people's facial expressions is essential to understanding how they feel and even who they are. The same is true of reading your baby's expressions. Her facial and bodily expressions are your window into her feelings and personality—into her inner life. Each of her expressions is telling you just a little more about her, about what matters to her at this time, what makes her happy or sad. But it is your baby's social smile, which may appear between one and two months of age, that is especially thrilling, because this special smile tells you how your baby feels about *you*.

Shortly after your baby's first simple smiles appear, a qualitative change takes place, heralding the beginning of true social smiling. When you see your baby's first social smile, most likely during face-to-face play, you will recognize it instantly. This open-mouthed smile will be combined with a slight narrowing and focusing of the eyes and may even be accompanied by cooing or speechlike sounds that are clearly directed toward you. It is a smile filled with feeling, and you will experience it as a sign that your overwhelming feelings of delight and love are being returned—because that is truly what is happening.

With these first social smiles, you know immediately that your relationship with your baby has been transformed. This smile has penetrated both your hearts.

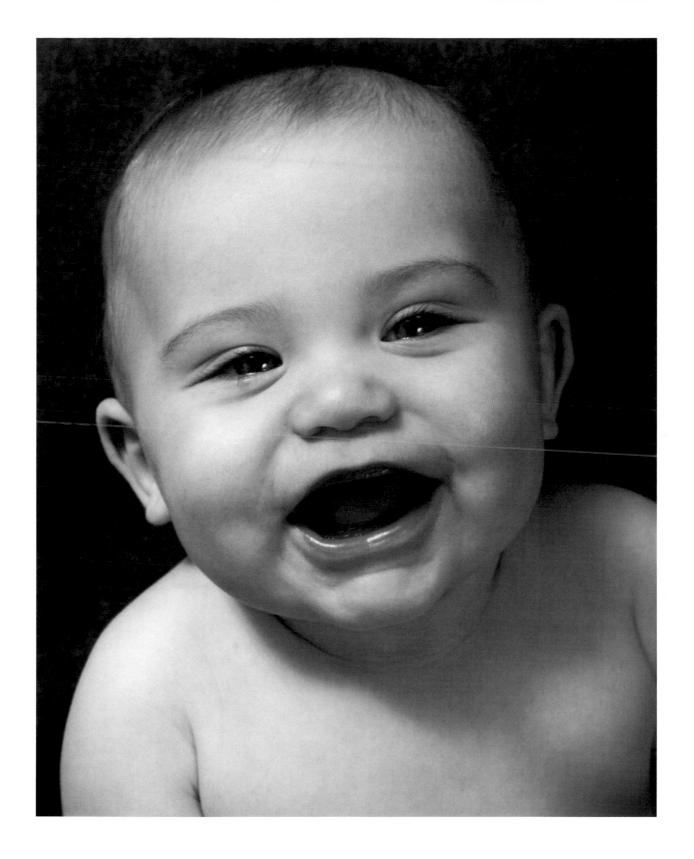

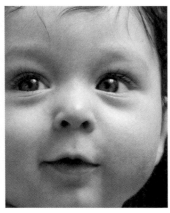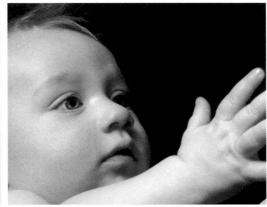

The Growing Baby, the Bigger World

Reaching Out

Everything your baby sees is new and interesting, and by nature he is drawn to reach out and examine it all. When he sees something that engages him, his eyes widen and brighten; his eyebrows may rise, his mouth open, and his jaw drop—all signs of interest and attention. During his first months of life, your baby can visually explore anything that draws his attention as long as it is within his visual range. He may even show some pre-reaching behavior by opening his hand as if to grasp an object.

However, at around four months of age, your baby's reaching capabilities undergo a dramatic change. At this point his visual capacity to detect detail improves significantly, and he can make nearly all the color distinctions that adults can. Now, after many weeks of trying, he finally has enough binocularity and depth perception to deliberately reach out and grab something that intrigues him, such as a set of dangling colorful rings. Look at the eager excitement and determination in this little boy's eyes as he pinpoints his target! You will see your baby make a series of attempts to reach for something. He looks at the object and then at his hand, moves his hand closer to the object, sights it again, and keeps trying to reach out until he can grab it.

Visually guided reaching is a spectacular achievement. For the first time, your baby is able to coordinate the information received through his eyes to control, guide, and direct his hands to accomplish the task he has set himself. Practice will make perfect, and at about six months, he will be able to reach out and pick up a tiny raisin with only his index finger and thumb. Over time, as his motor cortical system develops, your baby's reach will become smoother and more precise. But even in his early months, he can decide what he wants, then reach out and bring it within his range of vision for further examination. The world, with all its mysteries, is beckoning, and your baby cannot help but reach out and embrace it.

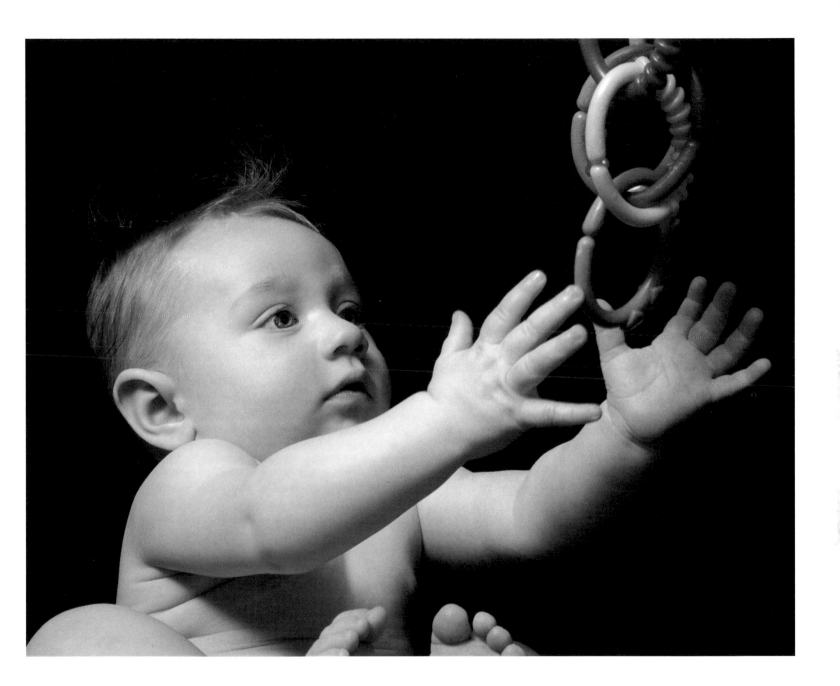

Exploring

THIS LITTLE BOY can now use his hands to actively examine his soft block, meaning that for the first time he is able to explore the world with all the senses he has at his command—sight, smell, vision, hearing, touch, and taste. He sees the block and reaches out for it; he adjusts his hands to touch and feel it; he listens to the sound it makes, smells it, and tries to put it in his mouth. He is able to perceive its weight, its texture, its hardness or softness by physically examining and mouthing it, rubbing and prodding it, and moving it around with his hands.

Babies are naturally driven to try to understand how the world of people and objects works. They are born with powerful inherent mechanisms that drive them to seek out and examine things and then to categorize and organize what they have learned about them. Even when he is only a few months old, your baby is testing hypotheses and conducting experiments with the tenacity and curiosity of a scientist! As he experiments with a new toy, he is learning to understand how it works and to form expectations about the future. He soon discovers that objects respond in certain reliable ways, that soft and hard surfaces are different, that blocks fall

down, not up. Experience with materials will teach him to modify, revise, reshape, reorganize, and replace his initial understandings. As your baby expands and refines his ability to explore his new world, he continually has to modify his way of seeing things. There will be errors to correct, misconceptions to revise, and ideas to expand on. But the ability to explore with both his eyes *and* his hands is already transforming his understanding of the world and changing the very architecture of his brain.

Above all, your baby is now learning that he can bring about changes in his immediate world. He can make things happen. In the next months and years, his expectations will change. There will be more uncertainty and more surprises. As he grapples with new challenges and novel experiences, his confidence will expand, and the sense of mastery he has now begun to experience will be enriched and deepened. He has already begun to understand that he can influence events in the world through his own actions.

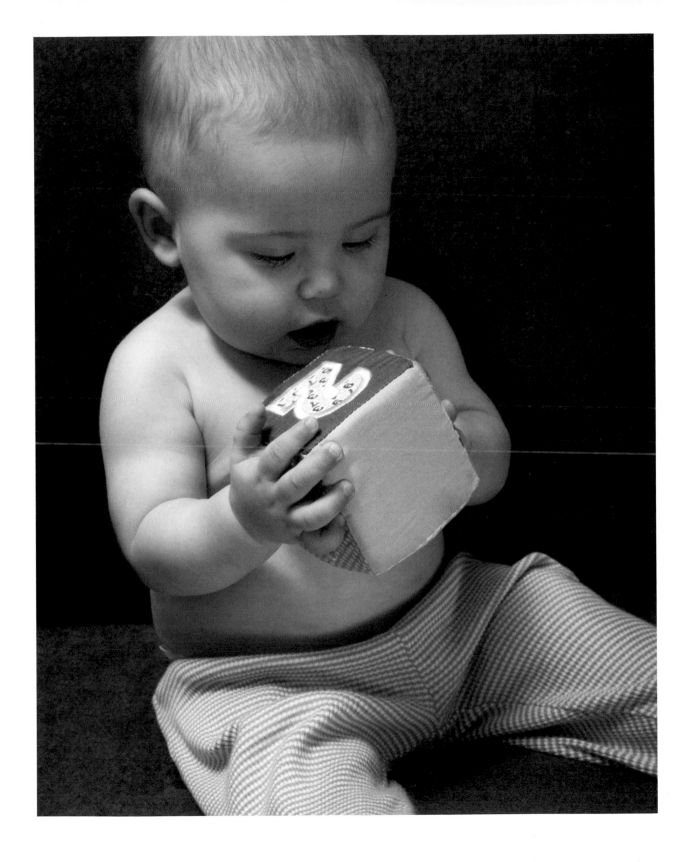

Empathy

Before your baby was born, you may have imagined the kind of person she would grow up to be, may have thought about the characteristics you wanted her to have. You surely hoped your baby would develop the capacity for kindness and empathy, among other traits.

There is evidence to suggest that even newborns may experience the basic ingredients of empathy —that is, the ability to identify with other people and even to take on others' feelings. Newborns, even in the first days of life, show greater and longer-lasting distress when they hear the cries of other infants. This response may be the beginning of a basic sense of compassion.

Nowhere is this nascent empathy more evident than in the relationship between twins. All twins, whether identical or fraternal, share so many experiences at the same point in their physical and emotional development that they inevitably forge a special empathic bond with each other. It is likely that the special relationship between twins lays the foundation for their growing capacity for intimacy and for affection toward others.

Every baby, whether a single child, a twin, or part of a larger family, will learn about love and kindness from you, his parents. But a child with siblings will also learn about compassion and concern from his daily interactions with his sisters and brothers. The birth of a baby has the potential to change and deepen family bonds. In the early months of life, especially, you as a parent have a unique opportunity to foster the relationship between your older children and the new baby, by including them in his care, perhaps by helping you dress or feed the baby or soothe him to sleep. This closeness—as in the bond between twins—will certainly influence your children's ability to cooperate and be sensitive to other people's needs, characteristics that lead eventually to the capacity for commitment and loyalty.

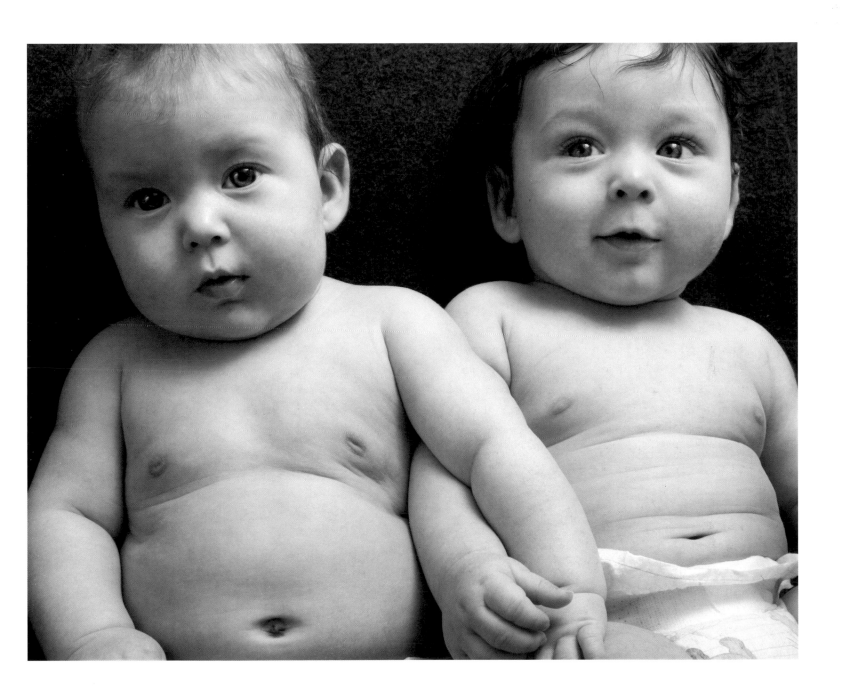

Learning to Love

OVER THE FIRST weeks and months of life, you and your baby have been learning to read each other's communication cues as you have come to know each other. Not only that, your baby is already developing different styles of conversation with you and with her grandparents, siblings, and caregivers, each variation with its own goal and aesthetic. Suddenly, between the third and the fifth month, there are more smiles—and even the occasional chortling belly laugh—more vocalizations and longer wakeful periods. The earlier hit-or-miss interactions have given way to a more fluid but structured form of shared play. Whether you are feeding your baby, giving her a bath, or simply talking to her, there is a beginning ("You're hungry, aren't you?"), a middle ("You really like this?"), and an end ("I think you are ready for sleep"). Now you and your baby have many more possibilities for improvisation, and play time can be very satisfying for both of you.

Some have referred to early parent-child play as a "ritual dance" because of its back-and-forth flow. But even though you will experience moments of perfect harmony, it's common to miss some cues and strike some discordant notes in your commu-

nication. You may fail to recognize your baby's unspoken request for a time-out and be too exuberant when she needs quiet. Like two adults, you and your baby may "talk" at the same time, interrupt each other, overlap in your interactions as you try to find a mode of dialogue that works for both of you. You may need to slow the pace of your speech or change the timbre of your voice to better fit with your baby's rhythms. The success of any dialogue depends on recognizing your communication mistakes and on trying to learn from them.

The foundations for conversation and language are undoubtedly being laid down in these early interactions. This is also how your baby can learn about true mutuality, about the give and take of caring exchanges between two people, and about the respect and patience necessary for relationships to thrive. Your baby is learning to love.

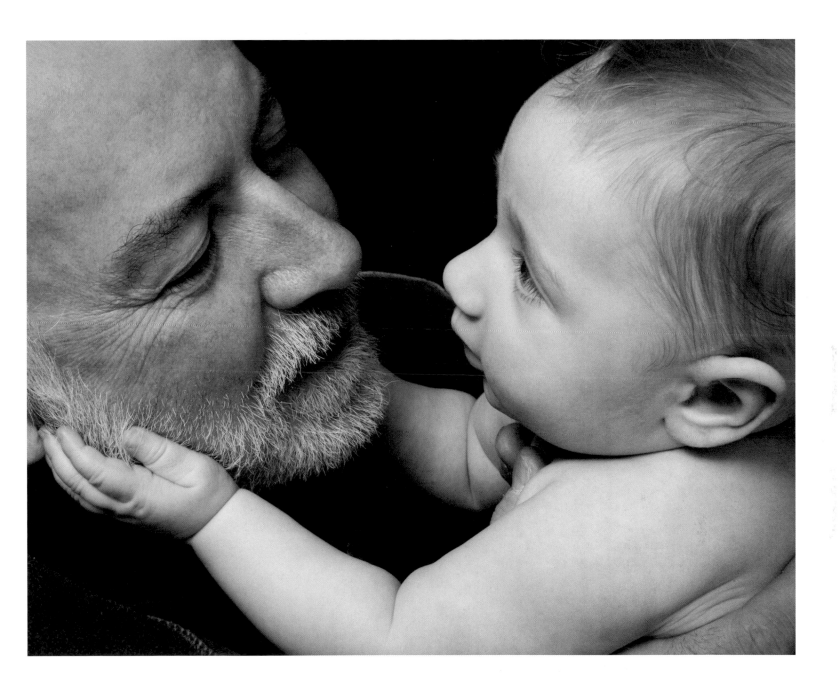

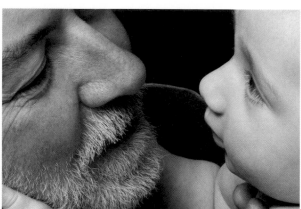

Parent and Baby and the Lifelong Bond

New Challenges

The newborn period and the first months of life are a time of extraordinary development and change for you and your baby. It is a time of profound personal adjustment, as you try to meet your baby's needs while you grow into your own skin as a parent. Every experience of every day with your baby is novel and fresh, demanding and exciting, and rarely predictable. You may feel that nothing could have prepared you for the almost bewildering array of questions and challenges your baby poses, whether it is making sure she has enough to eat and is getting enough sleep or searching for the best way to help her settle when she is distressed. These first weeks and months are thrilling, exasperating, and rewarding, and they are also critical for your baby's development, because together you and she have begun to lay down the foundations of a relationship that will last a lifetime. These days and months will remain embedded in your memory with vividness and clarity for the rest of your life. And at a deep psychological level, your baby will remember this time, too!

Your Baby's Expectations

Babies are born with hopes and expectations. Their need to be safe, to be cared for, and to be nurtured is a biological expectation. And babies can sense when their basic needs for security and love are being met. Your baby may not be consciously aware of this set of expectations, but it is built into his brain. He hopes that his cries will be heard, that he will be fed when he is hungry, that his need for sleep will be respected and protected, that his gaze will be met, and that his smiles will be reciprocated. When these expectations are consistently met, your baby will develop a profound sense of trust in you and in the world. This rich tapestry of experiences contributes to his feeling safe and loved, and that feeling will strengthen his attachment to you and give him a sense of his own worthiness, which is the foundation of his core sense of self.

Your Baby's Growing Competencies

Sometime between two and three months, you will notice a qualitative turning point in your baby's development and a marked increase in her level of competence. Almost without warning, she has reached a new stage.

She now stays awake and alert for much longer periods; she spends less time crying; and, as her vision becomes more precise and her hearing more discerning, she becomes more invested in what is happening around her. Above all, her capacity for social interaction is blossoming, and she seems to want to spend all her waking hours playing with you.

The change in behavior is all the more dramatic in babies who cried inconsolably or had colic during their first months. Some infants cry for up to three hours a day, beginning as early as three weeks of age, peaking between four and six weeks, and continuing for as long as three months. Parents may feel depressed or overwhelmed by a baby's persistent inconsolable crying, but to their great relief, most infants begin to cry less after the three-month mark, allowing prolonged, mutually enjoyable periods of play and exploration for the first time. This is a new beginning for colicky babies and their parents.

Your baby's sleep patterns are also changing. By three or four months, her nervous system will have matured enough that her sleep-wake patterns are more robust and reliable; both sleep and awake periods may last three or four hours at a time or even more. Still, every baby has her own characteristic pattern, depending on the development of her central nervous system and her temperament, so there is a wide range of variability in the time it may take for her to settle into a sleep-wake cycle. At this time, too, your baby's day-

night cycle—her circadian rhythm—begins to establish itself. She can now "tell" night from day and will begin to sleep more during the night than the day. Around two to three months, the pineal gland located in the center of the brain begins to produce the hormone melatonin, which gives the baby an internal clock that helps regulate her sleep-wake cycle. Although each baby is different, and some take longer to establish a circadian rhythm, by six months most babies will be sleeping though the night with one or two awakenings.

Your baby's weight tells a lot about whether she is feeding and absorbing nutrients well. By four months of age, she will have more than doubled her birth weight and will have grown four to five inches. As her growth acceleration and nutritional needs increase, her pattern of feeding also changes. Breast milk is still the perfect food at this age, although at around four months she may need supplementary solid food. You will find that the time between feeds is longer and her feeding schedule is more predictable. The baby's schedule and the family schedule are moving into a more synchronous relationship. Nevertheless, if you are working outside the home, it may be challenging to fit the baby's feeding needs into the family schedule.

Your baby's posture and her head and shoulder tone will become stronger over the next few months, and soon she will be able to sit while reaching out to examine an attractive toy that catches her attention. These new abilities

open up an exciting new world of opportunities, which your baby will be irresistibly drawn to explore. Observing and listening may still be her preferred mode of learning, but now she can learn by actively experimenting with her hands as well. By four months she can retain and examine a toy that is placed in her hand, and by five months she can grasp a block and even transfer it from one hand to the other. Then, at about five or six months, she will begin to push herself up and begin to crawl—moving outside the immediate orbit of your arms and lap—and by the end of the first year she may have taken her first step and spoken her first word.

The Social Baby

What you will notice, perhaps above all else, over the next few months is that your baby looks at you differently. His social capacities begin to flourish between three and five months. Because he is still unable to move around on his own, his world is truly centered on his interactions with you, but now he is ready for longer and longer periods of face-to-face socializing. He can control his gaze almost as well as an adult, and simply by looking at you he can draw you in and engage your attention. You may find yourself locked in long, sometimes silent periods of mutual gazing into each

other's eyes. There is no agenda: you are simply enjoying each other's company, contemplating and getting to know each other. Your baby's gaze has become more penetrating, more "knowing," as if he can see into your soul. Over these next few months these moments become more intricate and complex as he becomes expert at regulating his face-to-face interactions. He may expand an encounter by smiling broadly and releasing a chortling belly laugh, and you will find that he can end an interaction by simply turning away. In these moments, your baby's appreciation of communication and language is being established. Above all else, you and he are laying down the foundation for a relationship that will last a lifetime.

The Forgiving Baby

his early interaction between parent and infant is often described as a "ritual dance" akin to the courtship rituals of some animal species, in which the couple dazzlingly matches and mirrors each other's every movement. But that is an idealized description, and it can carry the expectation that you and your baby will always interact in perfect synchrony. Such an unrealistically high standard can intimidate parents and cause them anxiety. As in any developing relationship, the interactions between you and your baby are com-

plex and challenging. Misunderstandings and missed opportunities for communication are to be expected. You may get annoyed with your baby, or even angry at her, when she cries inconsolably at night or fusses or squirms when you try to get her dressed.

Fortunately, babies are forgiving. After an unhappy episode, your baby will always allow you to get back on track. She will give you many opportunities to learn from your mistakes so that both of you can again enjoy your interactions.

Looking Toward the Future

he face-to-face turn-taking that makes up so much of your time together over the next few months is the foundation for your baby's communication and thus the basis for all his future interactions in life. Because this is a period of rapid brain development, every social experience will result in a major transformation in many neural functions in his brain. Every time you return his smile, every time you are able to relieve his cry of distress, every time you satisfy his hunger, electrical impulses that foster brain development are stimulated.

The way you act toward your baby gives him an internal model, an expec-

tation, for the way people should behave with one another. The give-and-take of your play together offers your baby a critical lived experience of respect and tolerance, of forgiveness and restoration. Above all, these early transactions offer lessons in what it is like to love and be loved unconditionally. Your baby comes to understand that he is lovable, that he is worthy of love, an understanding that continually contributes to the enrichment of his inner sense of self.

Hope and the Newborn

ife is a flame that is always burning itself out, but it catches fire again every time a child is born," wrote George Bernard Shaw. For many parents, the world of the future may appear challenging and demanding, even daunting. The newborn baby offers us the gift of hope and, with that hope, a fresh vision that can sustain us as we face the future. In her untouched perfection and infinite promise, a newborn is an antidote to sadness, to disappointment, and even to despair. Babies renew and transform us, charging us with the passion and energy we need to face the uncertainties of life. The birth of a baby may be the supreme moment when, to quote Seamus Heaney, "hope and history rhyme."

Author's Note

꘎ I feel privileged, indeed honored, whenever I am able to spend time with a newborn baby. That parents allow me to hold and interact with their baby at this remarkably sensitive time in their lives never fails to move me. Yet it is the newborn baby, in all his amazing perfection and responsiveness, in all his uniqueness and personableness, who charges the occasion with a sense of expectation, drama, and awe. The newborn's capacity to elicit our purest instincts for nurturance and care makes the neonatal examination unforgettable for all who are fortunate to be present.

It was with a familiar sense of deep appreciation and anticipation that I undertook the examination of each of the babies whose photographs are in this book, first during their earliest days of life at Brigham and Women's Hospital in Boston and later in their homes. I had the opportunity to share in the

parents' excitement as we used the Newborn Behavioral Observations (NBO) system to examine a one-day-old baby's hand grasp or stepping response, watch another infant track a red ball with fluid eye movements, and yet another turn to the sound of a parent's voice. I was touched and impressed by the parents' energy and passion and by their hopes and dreams for their babies' futures. I am profoundly grateful that these visits have become part of the family story for many of these babies.

Each session was made more memorable both for me and for the parents by the presence of the great photographer Abelardo Morell, whose personal warmth and deep respect for babies is reflected in the photographs in this book. His sensitive eye allowed us not only to document each baby's amazing competencies but also to capture the subtle, almost imperceptibly fleeting expressions that offer a window into the baby's mind and soul and give us a clue to her "language."

In writing the text of this book, my goal was to inform without being pedantic, to be concise and still do justice to the richness and precision of the research underlying the behaviors I describe. I hoped to make our research discoveries accessible and provide parents with trustworthy, helpful information without being prescriptive.

Collaborating with Abe Morell was a singular honor for me. I was also for-

tunate to be able to work with Abe's assistant, Aimee Fix, a graduate of Massachusetts College of Art, who is now moving from photography into the field of medicine. She organized every shoot with artistry, polish, and good humor. My daughter, Aoife Nugent, a graduate student at Pratt Institute, was the coordinator for the project, which made for an unforgettably enriching and happy working experience. Aoife's professionalism meant that we never lost sight of the needs of the babies and their families, even as we adhered to an ambitious schedule. To observe and photograph these babies during their first hours and days was an extraordinary privilege, made possible by the kindness of the doctors, nurses, and staff at Brigham and Women's Hospital. We are deeply grateful to them.

As we undertook the task of combining photographs and text, Lisa McElaney contributed her expertise and wisdom; Joseph Nugent and Una McGeough-Nugent offered a critical first look at the text; and my research colleague, Nancy Snidman, reviewed the psychological content. I would also like to thank Peg Anderson for her remarkable line editing. This collaborative effort would not have been possible without the encouragement and the generous and indefatigable support of our editor, Deanne Urmy, who made the whole project possible in the first place. She edited the text with expertise and patience and guided us every step of the way with grace and style.

Throughout the writing of this book, I was constantly reminded of how fortunate I was to have studied newborns under the guidance of Berry Brazelton at Children's Hospital in Boston. Along with Berry, Heidelise Als and Constance Keefer introduced me to the world of newborns. Their scholarship and dedication to infants and their families have added much to my life over the years, and many of their insights and indeed their values have been translated onto these pages. I also offer sincere thanks to my colleagues at the Brazelton Institute, Susan Minear, Lise Johnson, Yvette Blanchard, and Beth McManus, who have taught me so much about the language of babies and who have always given babies and parents the respect they deserve.

Finally, to the babies themselves and their parents I can only say with deep admiration and appreciation, *go raibh mile maith agaibh* — a thousand thanks.

Photographer's Note

∽ When my wife and I became parents, my life as an artist changed dramatically. Becoming a father changed my life as an artist. Paying attention to my own infants made me want to feel and picture life in new ways. Whereas in the past my photographs had relied on fracturing the world into surreal tableaus, new pictures of family dealt more frontally with the senses and brought me a closeness unknown to me before. Photographically life seemed slower — things became more intense in the act of looking. I'm convinced that the work I have made since reflects those early days of fatherhood when a brand-new being demanded my undivided attention and in the process drew invention out of me.

First I want to thank my wife, Lisa McElaney, whose professional research

and insight into the world of early childhood was inspiring, eye-opening, and invaluable to me as I made these pictures. Indeed, it was she who convinced me that I would make a good photographer for the project.

I loved making the pictures for this book. It was an honor to work with Kevin Nugent, whose gifts as a medium between babies and the rest of us are nothing short of miraculous. Also, I'll use any excuse to be near babies if only to remind me of why I became a father in the first place.

I would like to thank my assistant, Aimee Fix, whose photographic skills were invaluable in this project. Her guidance often made for better pictures.

The text of this book was composed by Melissa Lotfy in Monotype Dante. Dante was created in 1954 by Giovanni Mardersteig, a book designer, typeface artist, and printer, and Charles Malin, a skilled type punch-cutter. The two worked to develop a typeface that would be legible and elegant. The creation of Dante took six years and was Mardersteig's greatest achievement. The face was first used in Boccaccio's *Trattatello in Laude di Dante*, hence its name. Monotype used the original punches of the hand-set type as a model to produce an exceptionally accurate digital interpretation of the typeface.